STORIES OF NATURE FROM THE FLORIDA KEYS
A park ranger's adventures in paradise, behind the lens & through the seasons.

By Kristie Killam

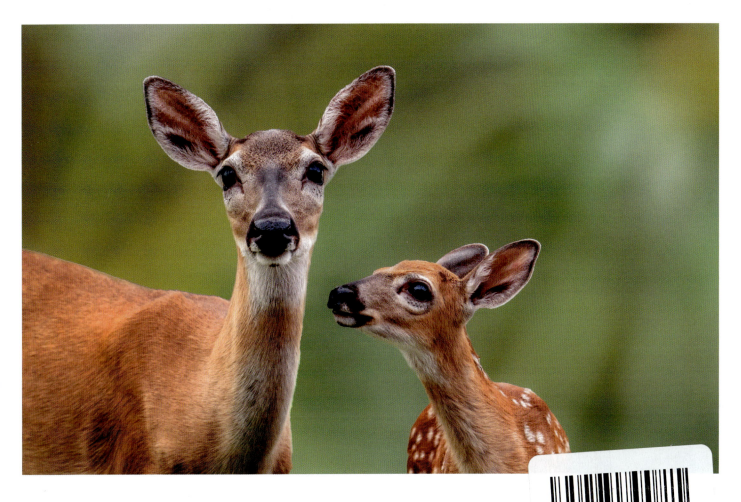

Photographer & Author Kristie Killam
Stories of Nature From The Florida Keys
A park ranger's adventures in paradise, behind the lens & through the seasons

Copyright 2025 by Kristie Killam

All rights reserved. Printed in the United States of America. No part of this book may be printed, scanned or reproduced in any form whatsoever without prior written permission from the author and publisher, except in the case of brief quotations used in critical articles and reviews.

ISBN: 978-0-9988589-5-1 (trade paper)

Library of Congress Catalog-in Publications data:
Killam, Kristie
Stories of Nature From The Florida Keys
A park ranger's adventures in paradise, behind the lens & through the seasons
Photographer & Author Kristie Killam
Editor & Designer Karuna Eberl

www.KristieKillamPhotography.com
www.QuixoticTravelGuides.com

Printed in the United States of America by
Versa Press, Peoria, Illinois

Printed on recycled paper with soy ink and other critical environmental considerations.

Dedication

To my husband, Randy, for his love and encouragement through the years as I wandered the woods and waters in pursuit of photographs, fresh air, and nature therapy.

To my parents, Rebecca and Scott, for fostering a lifelong love of nature and the outdoors, and who never complained if I had dirt under my fingernails or sand in my bathing suit.

To my siblings, Doug, Karen, and Sandy, who supported me through some challenging times and who cheered me on in writing this book.

And to all the people working and volunteering tirelessly to protect Mother Nature, you are superheroes! Your efforts do make a difference!

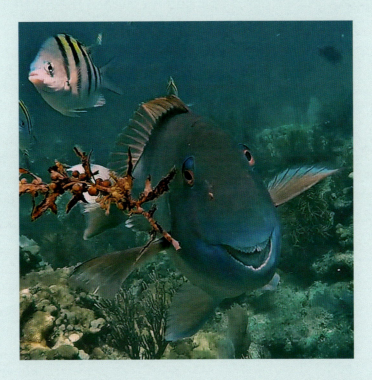

Acknowledgments

I thank my friend D. Cricket Desmarais for pushing me out of my comfort zone and emboldening me to make the leap from the idea and rough concept of an artsy nature book into reality. "Make a book, she said; it'll be easy! Apply for an Arts Council grant; oh, by the way, the deadline is Friday!"

But with her inspiration and wordsmithing guidance, I received the grant, and then there was no turning back. Our monthly brainstorming "meetings" at Goldman's Deli bolstered my confidence, fostered creative thinking, and made me laugh out loud.

I thank Karuna Eberl, my friend and book editor, designer, and creative mastermind, for bringing to fruition this notion of an intimate look at nature through photos and stories. While I wrote the stories that accompany the photos in this book, Karuna molded them into a uniquely clever and artful design presentation. Her creativity and imagination have no bounds. I eagerly looked forward to seeing her magic in each new book draft. Karuna's efforts carried me across the finish line, and for that, I'm eternally grateful.

And of course, I thank the Florida Keys Council of the Arts for awarding me a Special Project Grant to assist with publishing this book.
I am honored they entrusted me with creating this tribute to nature in the Florida Keys.

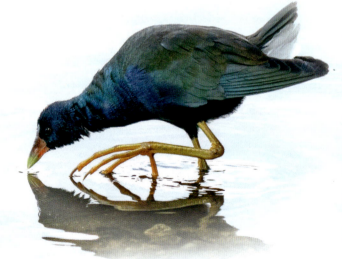

What's Inside

- About the Artist 6
- Visiting Keys Wildlife 8
- Winter 26
- Spring 58
- Summer 78
- Hurricane Season 100
- Autumn 114
- How to Help 144
- Public Lands List 146
- Index 155

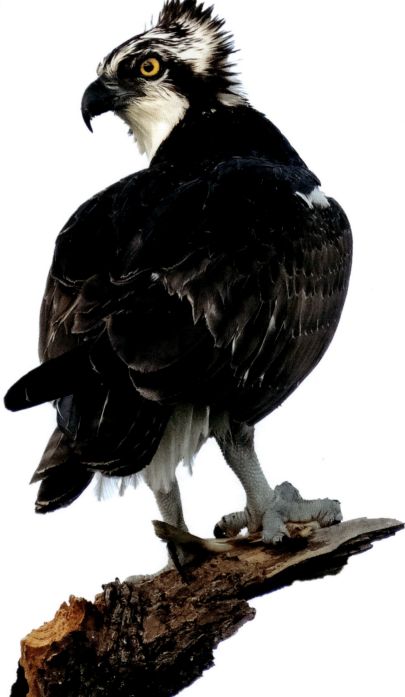

An osprey keeps a watchful eye while finishing off the morning catch, No Name Key.

About the Artist

I consider myself lucky to have grown up in a world free from the distractions of cellphones and the internet. We learned early on how to entertain ourselves; after-school hours and weekends were spent outdoors in our local woods, creeks, and reservoirs. Summer vacations included trips with family to upstate Pennsylvania, the Jersey Shore, and Nova Scotia, Canada, fostering a lifelong love of the woods, wildlife, and oceans. Mother Nature provided a safe haven where parents felt comfortable letting us disappear, as long as we were home for dinner.

Being exposed to the beauty of nature in such a deep and meaningful way as a child led to it becoming a big part of who I am today. I recharge my batteries and rejuvenate my spirit by heading out on the water or into the woods. Conserving nature has also always been an integral part of my life. My career titles have spanned from marine biologist, to environmental science teacher, to park ranger with the US Fish and Wildlife Service's Florida Keys National Wildlife Refuges, with a couple of other nature gigs thrown in there as well. Nature is just in me. I honestly think I'd go bonkers if I couldn't go outdoors!

Most recently, I've focused on taking photos of wildlife, plants, and landscapes in the Florida Keys. I've discovered that photography is a wonderful tool to capture unique stories and art in nature. Pictures are also a powerful way to communicate; they can evoke an entire range of emotions without a word spoken. I've created this book to arrange some of my favorites in one place. I hope they inspire you to go outdoors to create your own stories and memories, and to love and conserve our natural world.

Selfie of me hanging with my fishy friends. I snorkeled down, placed an underwater camera on the seafloor facing upward, and set it to take a burst of photos. Newfound Harbor, Big Pine Key.

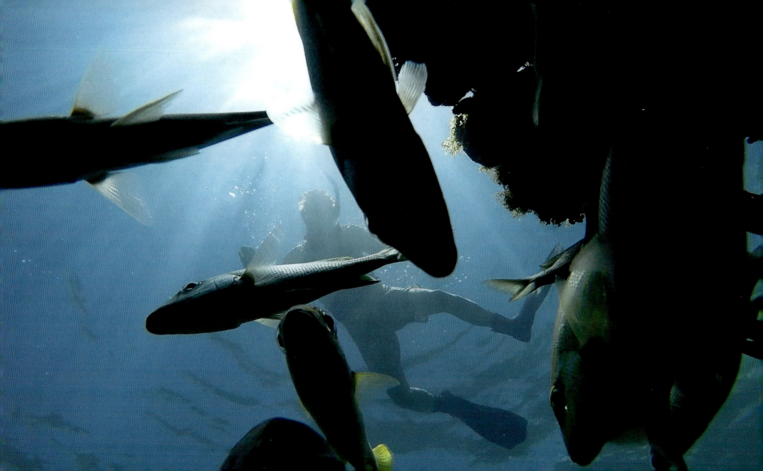

Reflections

The Florida Keys are an enchanting island chain, which extend about 200 miles southwest from the southern tip of Florida, through Key West, and out to the Dry Tortugas. Here, sun-drenched tropical landscapes and warm ocean breezes leave one feeling far removed from the mainland. I don't believe there is another place in the world packed into such a small geographic area with so many opportunities to explore and appreciate nature.

This place is home to four national wildlife refuges, is bounded by three national parks, includes ten state parks, and is surrounded by the Florida Keys National Marine Sanctuary. Wow! And that's just the big stuff; there are also many other smaller natural areas, all within a 120-mile drive!

The wildlife, plants, and habitats that call this place home are unique and diverse, with some found nowhere else in the world. Many are considered rare, endangered, or threatened, and need protection. Some creatures live here full-time, some come and go seasonally, some stop to rest and refuel during annual migrations, and others pop in randomly, giving people an exceptional treat.

One thing I love about being out in nature is her little surprises. On this morning at Coco Plum Beach in Marathon, I had hoped to photograph something entirely different, but that didn't materialize. When I turned around and looked out over the water into the rising sun, I saw a magical scene; a little blue heron silhouetted in the pink-and-purple-colored waves.

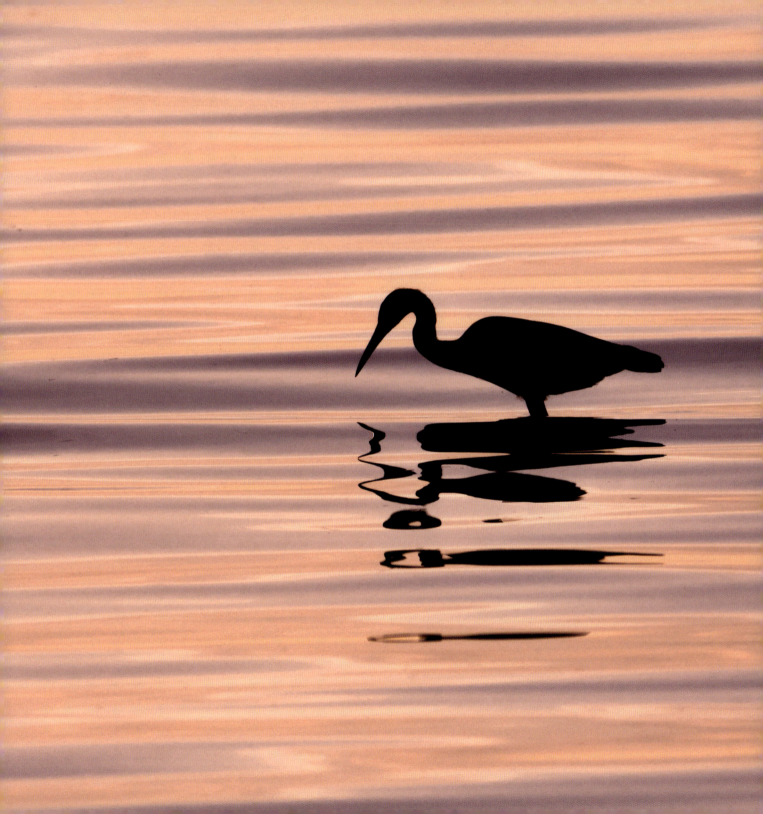

Confessions of a Nature Nerd

All of the photos in this book were taken on my own time, although throughout my ten-year tenure with the US Fish and Wildlife Service, I've used many of them to help tell nature's story. It thrilled me to know they were going toward a good cause, to educate our community, visitors, and those afar about conserving the Keys.

I've tried to keep the stories in this book on the upbeat and fun side; however, I would be remiss if I didn't also put out a plea for assistance. Each day, nature struggles to hold her own. Natural habitats are lost to development, protections for wildlife are under siege, and many global ecosystems are imperiled.

The Florida Keys are a living example of this; we struggle locally with issues like habitat loss, regionally with failing water quality, and globally with existential threats like sea level rise and climate change — all issues that impact our lands, waters, and the creatures who rely on them for survival.

You can be a voice and an advocate for nature. Change the way you live to consider nature's needs. Vote with nature in mind. Build a backyard habitat. There are tangible actions you can easily accomplish, some of which I've included at the back of this book. Thank you for taking a moment. Together we can make a difference!

A while back, the landscape surrounding the Refuges administrative building was stark and devoid of vegetation. One of the biologists suggested we add native plants and trees, so we had a staff workday outside, bonding with one another and creating a backyard habitat. Within a few months, endangered Lower Keys marsh rabbits began to visit. They ended up liking it so well that they stayed to raise their young. Ten years later, you can still see generations of marsh rabbits romping around the building in the mornings and evenings.

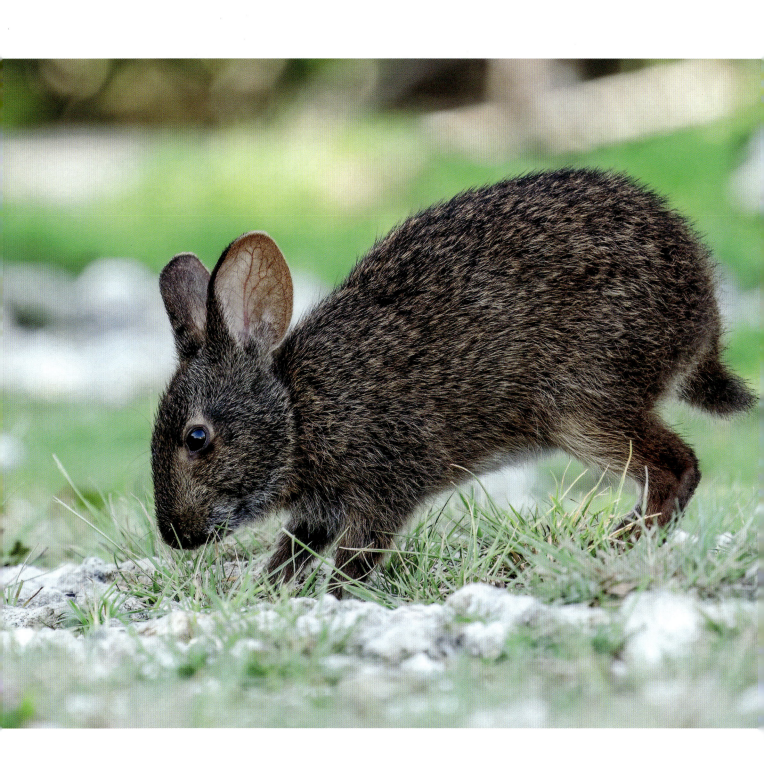

Message from the Wildlife

Visit gently! We live here.

When visiting the Florida Keys, get advice from human wildlife experts to help craft your experience. Explore the many nature and visitor centers in the Keys to ensure a fun and safe visit for all.

Sometimes people give us the heebie-jeebies! We need our personal space. Please don't chase us. Use binoculars or a telephoto lens to get close.

Mother Nature has given us all the skills we need to survive. Don't feed us; we know where to find food and water. When you change our behavior, you put us in danger. (Plus, it's illegal.)

Please appreciate our wild side. Don't try to touch or pet us. That's what puppies are for.

Drive carefully in Key deer country, which includes Big Pine and No Name Keys, west to Lower Sugarloaf Key.

Let nature be. Please don't pick wildflowers. Leave shells, rocks, and driftwood. Those are precious homes and resources to others.

Photo right: tricolored heron giving us the "please visit gently or else" look.

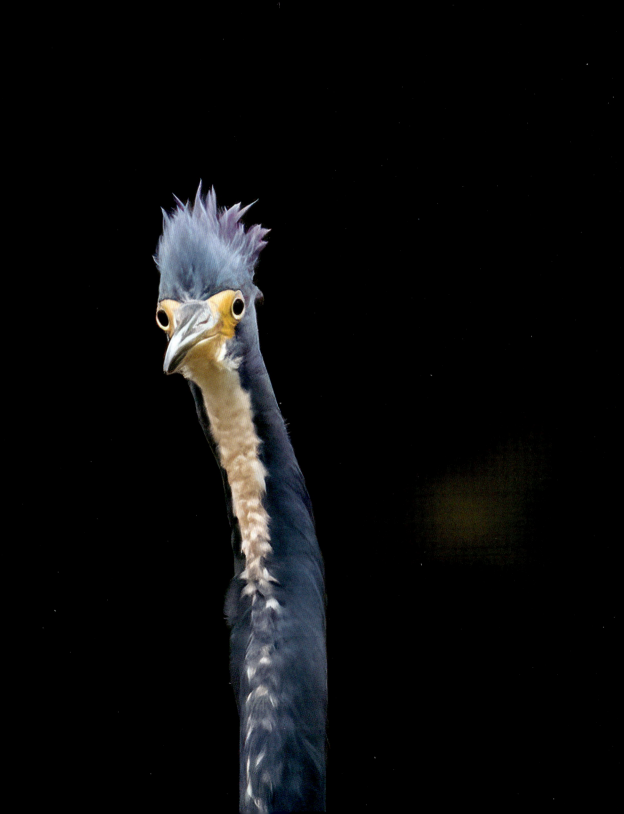

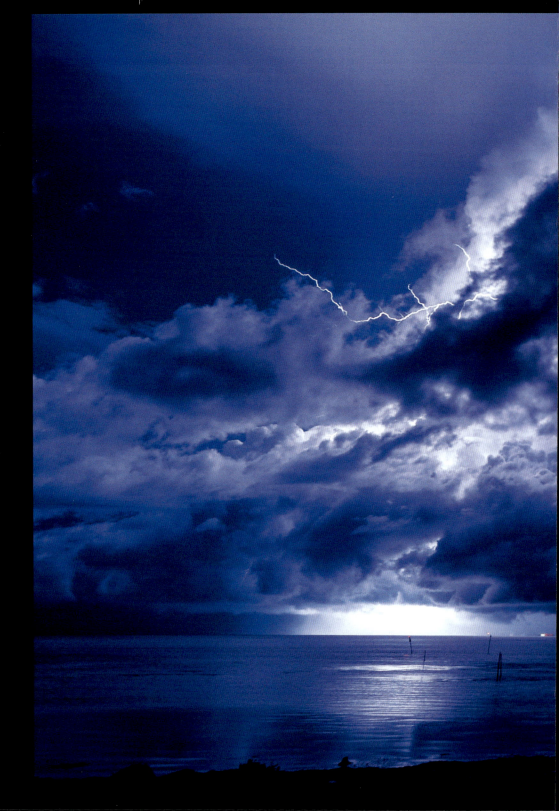

We don't have mountains or undulating topography here, but many people consider our ever-changing cloudscapes equally dramatic. Summer storms produce fantastic light shows. I set my camera's shutter speed to a lengthy exposure of 20 seconds to allow time to capture this exhilarating storm within one photograph. (No Name Key.)

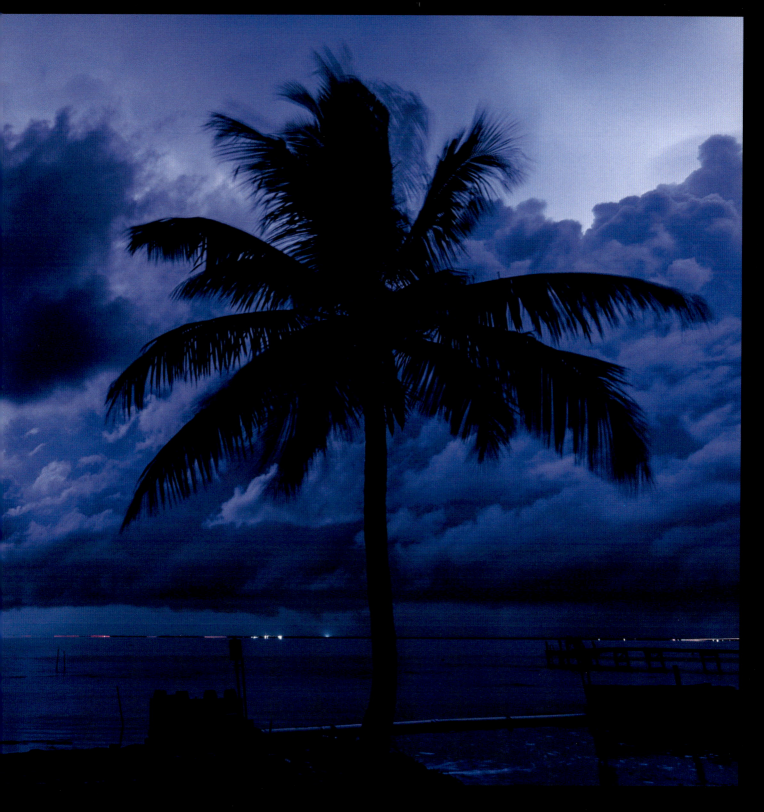

Charismatic Megafauna

The wild subjects in this book loosely fall into two categories: celebrated megafauna and underappreciated creatures — on land, wing, and undersea.

Charismatic megafauna describes the famous stars of the animal world, who garner a lot of the public's attention and support. The Florida Keys are flush with these, including Key deer, sea turtles, manatees, and bottlenose dolphins. To have the opportunity to see creatures like these in the wild is nothing less than awe-inspiring.

It might seem unfair that just a few of the thousands of plants and animals receive the bulk of public attention, and I agree. As a park ranger, I did my best to foster an appreciation of the entirety of life bursting forth from our islands and waters. Still, I'd also argue that love and support for the chosen few can act as a driving force in wildlife and habitat conservation, which in turn benefits the entire ecosystem.

For example, endangered Key deer were hunted almost to extinction in the early and mid-1900s. After people rallied to protect them, the National Key Deer Refuge was created, which also protects thousands of other plant and wildlife species from habitat loss and degredation — and we have charismatic megafauna to thank for that. Plus the refuge is an excellent place for people to visit and explore, too!

I recommend getting out there and appreciating the mega cuties, but also leaving time to check out the unsung heroes of our natural world; their stories will warm your heart.

Photo: A Key deer doe pauses at an inland salt pond on Big Pine Key.

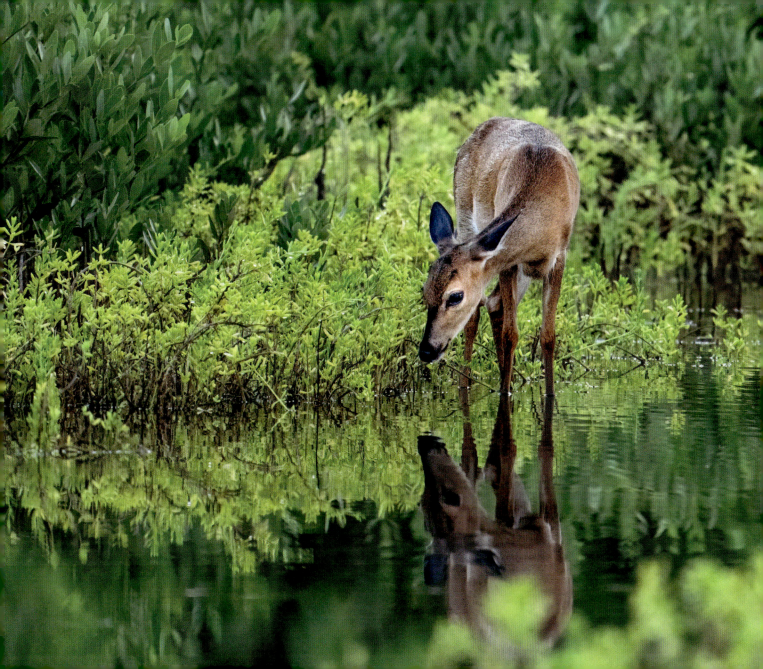

Commonly Uncommon & Interconnected

As much as I love watching and photographing charismatic megafauna, I'm also drawn to the unsung heroes of our natural world. These plants and animals live amongst us, and often we don't even give them a second glance. But they are all part of an elaborate, interconnected web of life, and they deserve to be celebrated, too! I'll introduce you to some of my favorites in this book.

Consider the white ibis. They are common throughout the southern US. As adults, their white bodies, black wingtips, and red faces and legs make them hard to miss. People often ask about the purpose of their curved beaks: they act like tweezers as they probe for small fish, crustaceans, or other invertebrates. They'll poke around in wetlands, often walking behind other wading birds, and watching for prey that has been stirred up.

White ibis are gregarious, choosing to hang out with one another in groups. I divide them into two not-so-scientific categories: city and country. I've seen a flock of twenty city ibis hanging out in a parking lot in Key West, immune to the hustle and bustle around them; but I've also witnessed a flock of about a hundred country ibis take off from a hidden roost after hearing a twig snap as I tried to walk quietly through the woods. Amazingly, both types have adapted to flourish in widely varying conditions.

I happened upon this white ibis probing around a freshwater marsh on Big Pine Key one evening. Ibis are year-round residents and also make good photography subjects, since they aren't as shy around people as many birds. I purposely overexposed this image to give it a high-key look. High key photos are bright with few shadows, giving them a fine-art feel.

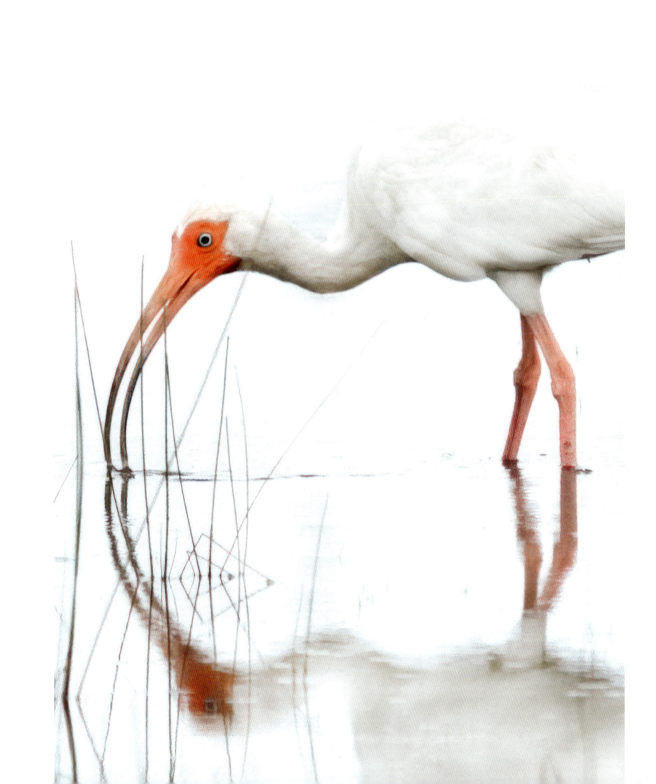

Aquatic Adventures

"Believe me, my young friend, there is nothing — absolutely nothing — half so much worth doing as simply messing about in boats."
— Kenneth Grahame, The Wind in the Willows

Water is in us, and all around us. It is the essence of life here in the Florida Keys. It's also a great place for people to connect with and experience nature. If you get a chance and are so inclined, I encourage you to get out on the water for a salty aquatic adventure.

Visit the coral reef for a snorkel or dive. You'll disappear into a peaceful inner space where the rest of the world quickly fades into the background. Go kayaking or paddle boarding over shallow water habitats. You'll be captivated as stingrays and small sharks pass under your bow. Go fishing and bring some home for dinner or release them back into the sea. Give wild swimming a try. Wear a mask and be entertained as you exercise!

I met this school of gray angelfish while snorkeling in about eight feet of water in the Great White Heron National Wildlife Refuge. The juveniles use backcountry coral heads or rocky outcroppings as nursery areas. When you snorkel down for a closer inspection, you'll typically get a quick once-over by the entire school to ensure you aren't up to something nefarious.

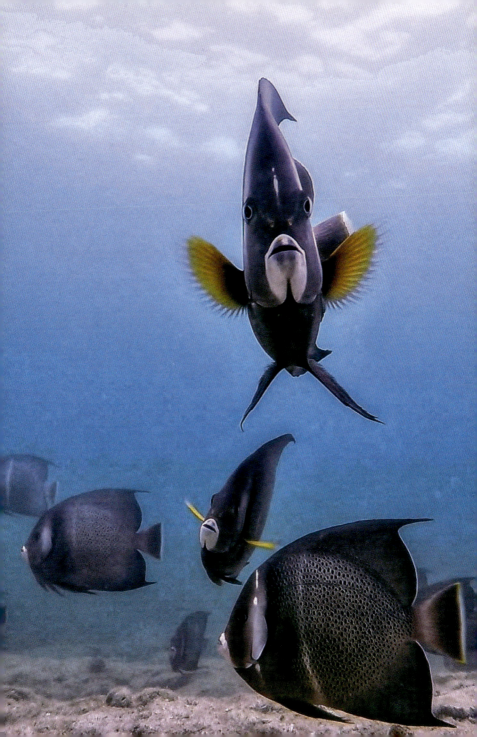

Hidden Gems

I definitely recommend exploring the large federal and state natural areas in the Keys, but don't miss out on the smaller hidden gems, either. There are dozens throughout the island chain, each with its unique story (see page 148 for a list.)

One of my favorites is the Key West Tropical Forest & Botanical Garden on Stock Island. That is where I spent my first year of employment in the Florida Keys. As an educator, I helped teach nature classes to local elementary school students. I think I learned as much as the kids, as the tropical plants and their ecological relationships were new to me, too.

The Garden's 15-plus acres serve as an oasis for wildlife and people. It's quiet and peaceful inside the gates, a stark contrast to the nearby traffic on US 1 and busy Key West. More than 200 species of birds and almost forty species of butterflies have been documented here. That's huge.

Many of us are all too familiar with watching paradise turn into pavement. Here and there, though, there are heartwarming stories of how the reverse is possible. A few years ago, the Garden removed a large concrete pad that was home to a WWII military hospital. A natural freshwater pond, which had been buried underneath for decades, was reborn. The restoration was just underway when I worked there in 2008, but today, as shown in the photo, nature has visibly recovered and is flourishing.

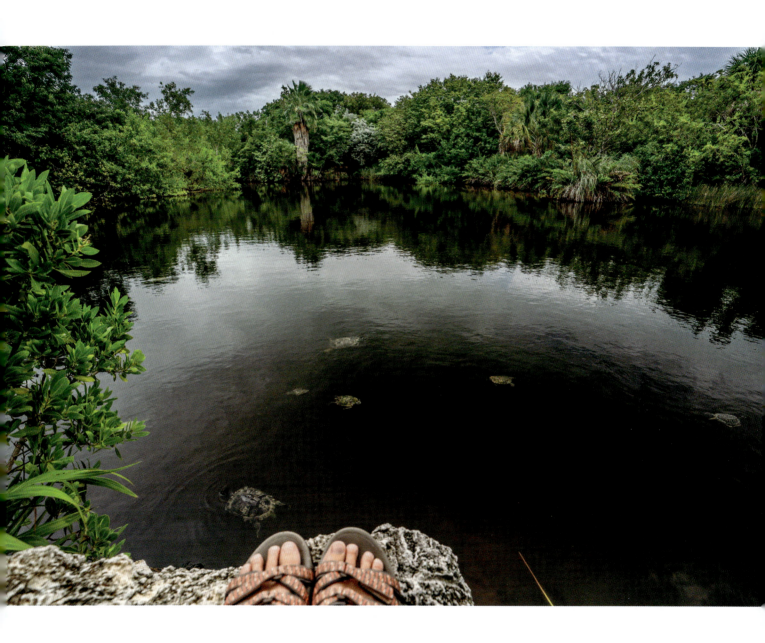

Seasons in the Florida Keys

One might be inclined to think that a place like the Florida Keys, nestled in a warm subtropical setting, wouldn't have much in the way of seasonality. That couldn't be further from the truth. Plant and wildlife life cycles are closely tied to changes in air and water temperatures, day length, rainfall, and many other variables.

Rainfall, or lack thereof, plays a prominent role in determining what happens when. The dry season, where sunny skies and cooler temperatures prevail, generally runs from November to March, and the wet season from April to October. The wet season gives us the bulk of annual rainfall essential to life for many terrestrial (land) species.

The stories in this book follow a typical year to honor these well-established seasonal cycles.

Seagrape leaves change from bright green to a lovely crimson as they prepare to drop their leaves in the winter. They are considered evergreen because they'll sprout new ones immediately.

Seagrapes grow as trees or shrubs and make beautiful landscape plants. Mother nature approves; their flowers attract pollinators and their fruits are eaten by Key deer, raccoons, and various birds. Seagrapes are edible, and taste like a regular grape, although rather pithy. I've had friends make tasty jams from them.

Winter *Paradise*

Winter months, December through February, are drier and less humid. Air temperatures average in the 60s and 70s, offering a much-needed respite from the heat. Intermittent cold fronts pass through, sometimes dropping temperatures into the 50s, but then usually pass within a few days.

Sustained cold weather, although rare, can dramatically affect sea life adapted to live in tropical waters. In January 2010, water temperatures dropped into the upper 40s to lower 50s for almost two weeks, stunning sea turtles, causing massive fish and manatee die-offs, and widespread coral mortality. Sometimes it can take nature several years to recover from such things.

Since we humans spend most of the year acclimating to intense heat, these sudden temperature decreases also have us scurrying for our socks and fleece jackets, but thankfully not our snow shovels. Most other land creatures adapt; birds fluff up their feathers to stay warm, Key deer thicken their coats, tree snails aestivate, and alligators, crocodiles, snakes, and other reptiles sun themselves on warm surfaces.

Belted kingfishers live year-round in most of North America, but are only wintertime residents in the Florida Keys. They are one of many species exhibiting sexual dimorphism, where males and females look different. This is a male; a female has an additional rusty-colored band on her breast. Kingfishers also have a loud, rattling call. I liken it to a laugh, as they often seem to use it while flying off, letting you know that your efforts at getting a good photo of them are slim to none.

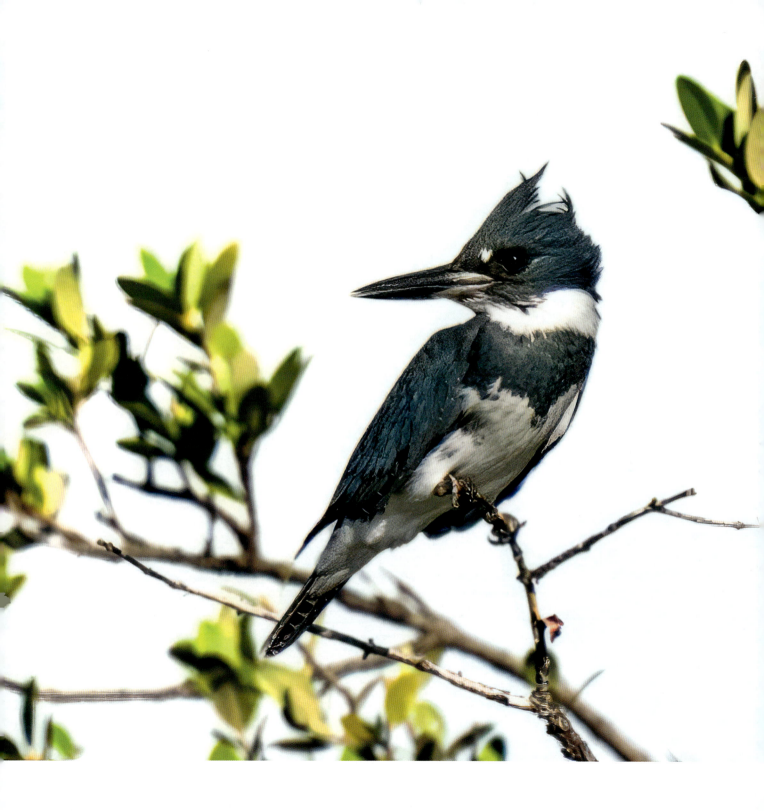

I Like Big Ducks & I Cannot Lie

This photograph of a blue-winged teal was the first image I took that felt like more than just a snapshot of an animal. It felt different. It had an artsy tone, and it conveyed an intimate look into the lives of these captivating creatures and their habitat. It really kick-started my desire to become a better photographer and storyteller.

To get the photo, I sat at an inland salt pond and waited. After 10 minutes, a small group of teal approached me. I kept rock still, heart beating rapidly in my chest. Not only did they come close, but they also dawdled around, allowing me to get some lovely photographs and appreciate their extraordinary beauty. I waited until they left, then quietly stole away, leaving them undisturbed. I love the sense of peace this photo provokes.

Blue-winged teal arrive in the Florida Keys during the fall migration, heading southbound from many parts of the US and Canada. In September, the males are sporting *eclipse plumage*; they look similar to females and are well camouflaged. As the months progress, males molt into their more distinctive breeding colors, with a white crescent mask, before heading back north.

These plump ducks are adorned with subtle organic colors on the outside, but hidden on the inside, their wings are gorgeous, decorated with metallic blues and greens. They aren't the easiest birds to view or photograph. Like many ducks, they are shy and skittish. They talk to one another in little peeps when they detect danger. If you hear the peeps, they know you are there. In the Keys, you're likely to spot them in inland fresh, brackish, and saltwater ponds from September through April.

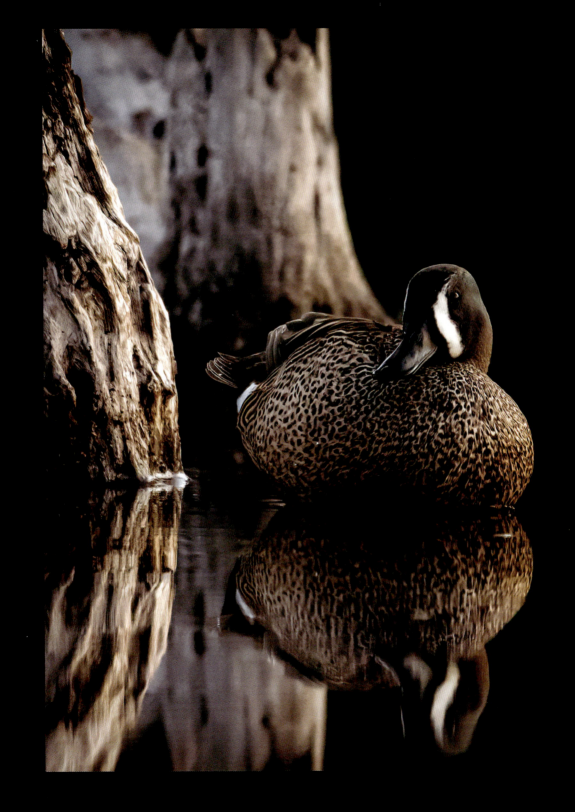

Winter White

The Keys are shielded from snowstorms typical of northern climates. However, we aren't missing out, because winter's snowy tones are heralded by soaring American white pelicans. These large birds, second only in size to California condors, stay the entire winter and into spring before heading north to their breeding grounds in the west-central US and Canada.

White pelicans have a feeding strategy that differs from their cousins. Brown pelicans deftly plunge from heights onto unsuspecting fishes. White pelicans, on the other hand, work as a team, encircling fish in shallow waters and dipping in their beaks simultaneously. Watching this water ballet in action is a marvel, and a primary culprit for making me periodically late for work!

Photo: American white pelicans relax after breakfast on No Name Key.

Where to Find White Pelicans

I've regularly seen white pelicans in Great White Heron and Key West National Wildlife Refuges, feeding in shallow seagrass or roosting on sandbars. They'll also gather in numbers at inland salt ponds throughout the Keys, especially as waters evaporate at the end of the dry season. These shrinking pools improve access to fish, crabs, and shrimp, helping them gain strength for the upcoming migration.

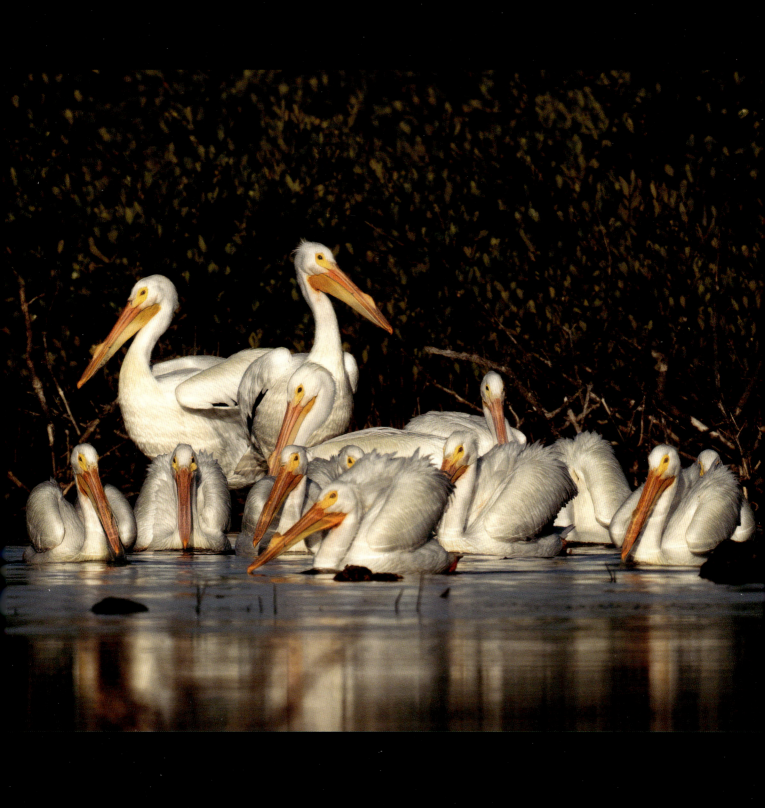

Life On The Rock

In the Florida Keys we jokingly say we're "living on the rock," and that's true because of our fascinating geology. Two layers of limestone help determine what habitats occur where. From Key Largo to Big Pine Key, the foundational rock is Key Largo limestone. It's biological in nature, created by ancient fossilized coral reefs, and is relatively porous.

In the Lower Keys, from Big Pine Key to Key West, a second layer, called Miami Limestone (formerly called Miami oolite) covers the Key Largo limestone. This layer is denser and less porous, which allows rainwater to pool, creating permanent and seasonal freshwater surface wetlands, plus a deep freshwater lens (a layer of freshwater under the surface, but floating above denser saltwater). This gives life to a cornucopia of plants and wildlife not found, or rare, in other parts of the Florida Keys, including Key deer, Lower Keys marsh rabbits, American alligators, box turtles, Lower Keys mud turtles, dragonflies, crayfish, southern leopard frogs, narrow-mouth toads, and dozens of bird species.

The freshwater lens also fosters pine rockland habitat, an open canopy of south Florida slash pine, palms, and more than 250 plant species. In here, the limestone has eroded over centuries to create solution holes, which expose the freshwater lens. This one on northern Big Pine Key is called Geraldine's Pond. It makes a captivating subject for landscape photographers, if you can find it!

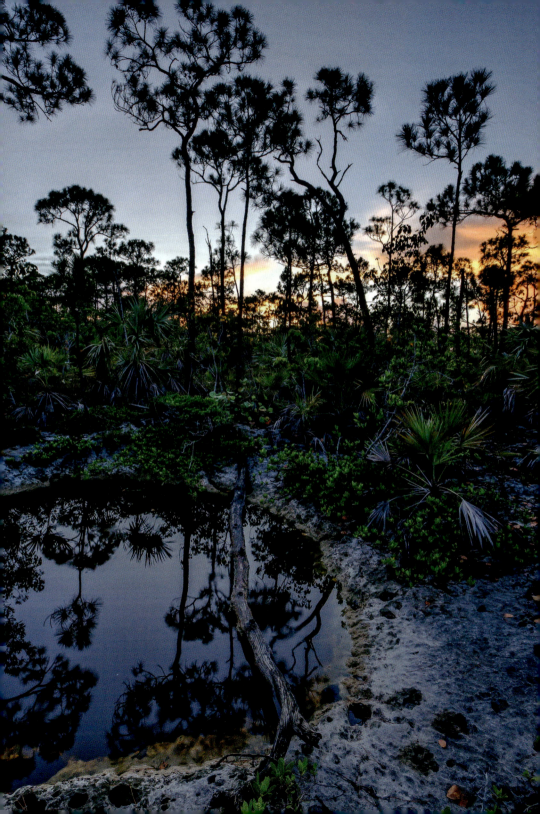

Who Goes There?

As the winter dry season prevails, many freshwater wetlands dry up. Of those that remain, evaporation causes salt levels to concentrate. Key deer and other wildlife have adapted to tolerate these brackish water conditions for brief periods.

I really enjoy finding a quiet place and letting nature come to me. I feel like it gives a more intimate look into the daily lives of these creatures.

I took this photo in mid-February on No Name Key, a little more than midway through the dry season. I sat on the other side of a large solution hole and waited to see what kinds of wildlife might happen by this little oasis in the pines. This deeper wetland offered a more permanent freshwater supply and was likely well-known to Key deer, raccoons, alligators, and birds who frequent the area.

Within a few moments, a Key deer buck quietly crept through the brush and waded in to get a drink. Instincts on alert, something within the dark cavern hollowed from the limestone piqued his interest — it was home to a small three-foot American alligator. In the Florida Keys, alligators are the only natural predators of Key deer, but one this small would not be a threat. Nonetheless, his senses were advising him to use caution. He drank for a few moments, then moved on.

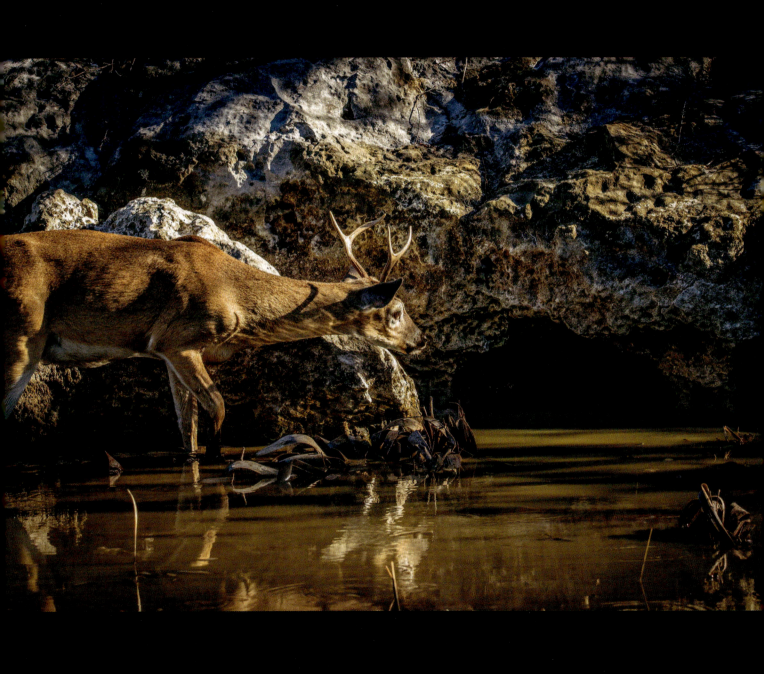

Large Lizards

South Florida is the only place American alligators and American crocodiles overlap in the wild. Crocodiles are found throughout the Keys but are more common in the salty and brackish waters near Key Largo. Alligators are more common in the Lower Keys, near freshwater wetlands.

A common misconception is that alligators are *only* found in freshwater. Keys alligators are frequently seen in saltwater, swimming along island edges and neighborhood canals. They seem highly tolerant of saltwater. We've had gators and crocs in our saltwater canal over the years, with gators constantly present. We affectionately refer to them as canal-i-gators, and have learned to live alongside them respectfully.

Both large lizards are carnivores. They'll eat fish, birds, turtles, and even Key deer. Both reptilian mothers guard their nests to protect their eggs from predators. Mother crocodiles dig up their hatching eggs and transport them in their mouths to the safety of the mangroves. After that, they are on their own. Mother alligators act similarly but keep watch over their babies for their first year or so.

I was standing alone on the observation platform at Blue Hole, examining the skies overhead for incoming birds and watching small tarpon leap toward passing dragonflies, when I noticed an alligator in the distance, effortlessly gliding toward me. It was inspection time. The gray skies caused a bright reflection on the water's surface, giving the photo an overexposed high-key look.

How to Help

Never feed these large lizards, either directly or by discarding fish scraps into canal waters. Both quickly learn to associate people with food, which can lead to behavioral problems.

Tracking Tiny Travelers

Defending nature involves people working together to solve problems, like protecting migratory wildlife that breed in one area and winter in another. How do they get from here to there? Are there critical rest stops along the way that need protection? It's a giant puzzle, but technological advances like Motus are helping to fill the gaps.

Motus is an international research network that uses radio telemetry to track migratory animals. Both the National Key Deer Refuge on Big Pine Key and Crocodile Lake National Refuge in Key Largo host Motus Wildlife Tracking Stations.

In 2020, Motus tracked a tagged painted bunting who departed South Carolina in October. From November 2020 until April 2021, he lived near the Nature Center on Big Pine Key. He then headed north around April 17, reaching South Carolina by April 25. Scientists now know where he was born, where he overwintered, and the rest-stops in between that need protecting.

Painted buntings are seed eaters who live in the southeast US and overwinter in Mexico, the Caribbean, and occasionally the Keys. The males sport an exquisite mix of red, blue, yellow, and green colors, like an artist's primary color palette. Females and young are a subdued yellow-green, helping them camouflage in the forests.

I'd come home from an evening walk one winter and was heading upstairs when a glint of red caught my eye. I assumed it was a male northern cardinal, but upon closer inspection, I realized it was a painted bunting — a bird I'd never seen. I about fell over myself trying to grab my camera! He graciously allowed me to photograph him nibbling on various grass seeds. I stayed for a while, then left him in peace.

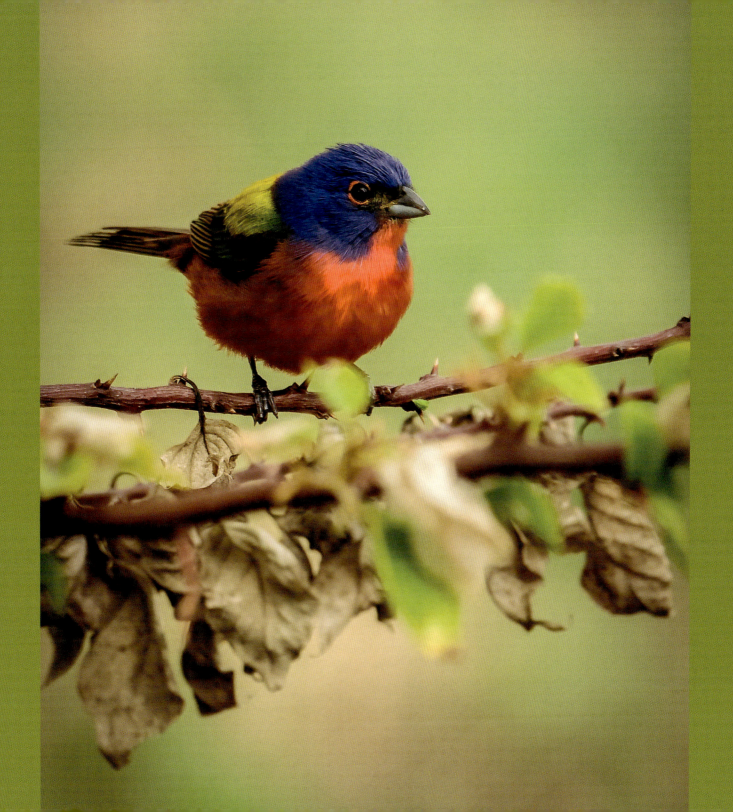

Life Lessons

Roseate spoonbills are some of the most beautiful birds who live year-round in the Florida Keys. Their bright pink feathers, red eyes, spoon-shaped bill, and warm smile make them a favorite among nature lovers and photographers. Juveniles' heads are feathered, and they sport lighter pink colors than adults. It takes about three years for them to reach maturity and go bald.

Spoonbills feed by sweeping their bills back and forth as they wade through shallow saltwater habitats, snapping up small fish, crabs, shrimp, and other aquatic invertebrates. Like flamingos, they get their pink colors from the foods they eat. Some crustaceans, like shrimp, contain red and orange pigments called carotenoids; when eaten, they are metabolized and ultimately give rise to the spoonbill's rose-colored plumage.

I was sitting at an inland salt pond on Big Pine Key, enjoying the peace and tranquility, when a lone adult spoonbill flew in and perched on a dead tree. Shortly thereafter, a young spoonbill silently approached from behind. He attempted to perch on the adjacent tree snag, but the adult was having none of it. She reached out and used her big bill to pinch and snap, even grabbing and shaking the younger bird's leg.

The scuffle went on for several seconds until the youngster decided there were safer places to land, and leapt away into the salt pond below. All of this happened so fast I just kept shooting; glad to have a camera with a high-speed shutter to capture the exciting details. Like humans, many animals have their own personal space needs. Without a word spoken, this youngster learned a valuable life lesson from a parent or flock member.

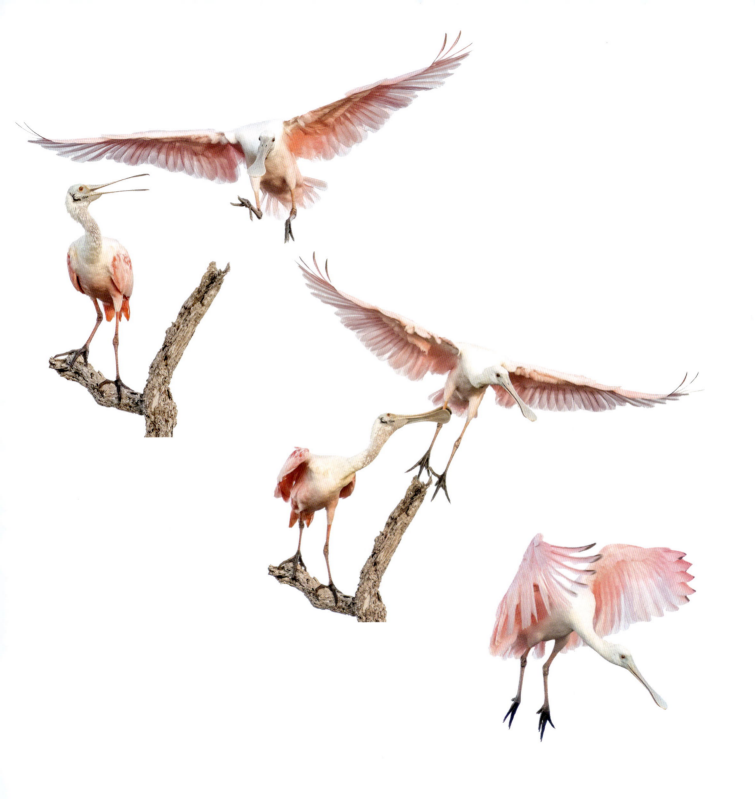

Never Say Never

My first job with the Florida Keys National Wildlife Refuges was an internship surveying freshwater wetlands. The refuge manager seemed embarrassed to offer it to me; the salary was far less than I'd been making professionally and barely enough to contribute to our mortgage and bills. I, however, jumped at the opportunity, hoping to get my foot in the door and gain more experience in the field.

I revisited 270-plus waterholes that historically had provided freshwater for Key deer and other wildlife. These were scattered throughout dozens of Lower Keys islands. It was physically demanding, often requiring boating and hiking through forests and scrublands to remote locations. We'd use a GPS to locate the water hole, take a salinity reading, record vegetation type, and look for signs of wildlife. Knowing how salty the water is can help determine if anyone can drink it. The surrounding plants also provide insight into whether it's a salty, brackish, or freshwater wetland, even if no water is present.

My associate sat on the ground and took out data sheets. I remember saying it didn't seem like any creature could drink here. No sooner had I spoken than a young raccoon appeared, walked right past my coworker, and dropped into the waterhole. She was just a few feet from us.

She put her head down, drank slowly for about ten seconds, then paused and looked around, never acknowledging our presence. She drank a little longer before casually climbing out and sauntering off. We were stunned for a moment, each silently asking ourselves if that had just happened, then laughing at our initial miscalculation.

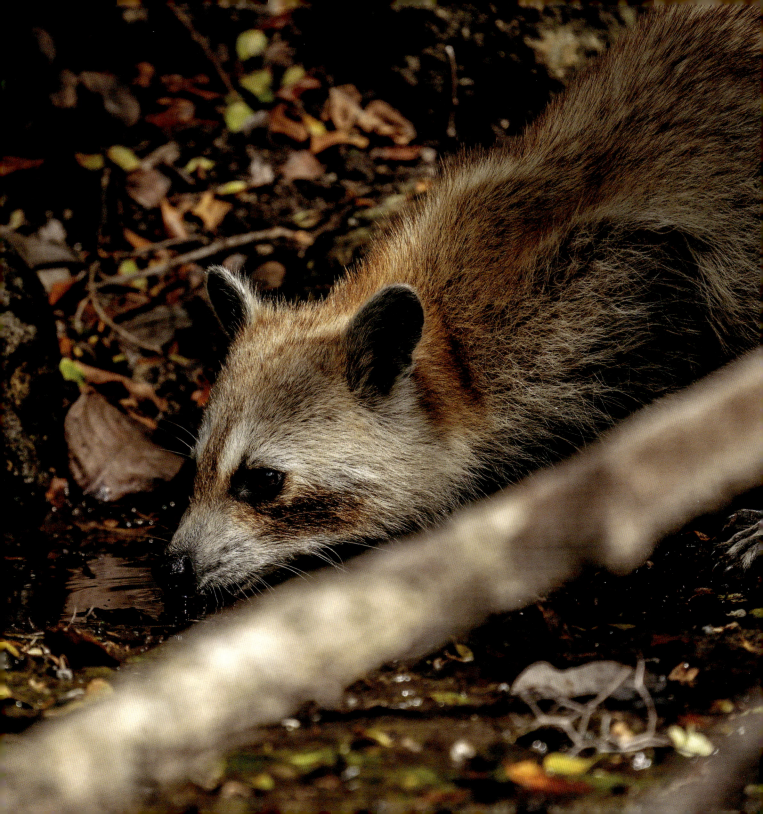

Dynamic Duo

Herons and egrets, like the reddish egret, are large wading birds who frequent wetland areas. There are about ten species who call the Florida Keys home. While most tend to be stealthy lie-in-wait hunters, the reddish egret is an exception. She prefers a dynamic fishing strategy, running around, then pausing to shield the water's reflection with outstretched wings, just before striking at a fish or shrimp. When she catches something, she'll shake it back and forth a couple of times to get rid of the water, and then deftly flip it up into her mouth to swallow it.

Reddish egrets are easy to identify. They are relatively large, with a distinctive bi-color pink-and-black bill during the breeding season. However, just to confuse the issue, reddish egrets in the Florida Keys have a white color morph, so they're sometimes mistaken for white egrets or herons. No need to worry, their signature fishing style holds the key to identifying them.

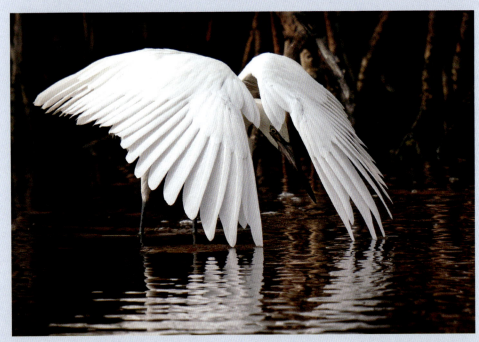

Reddish egrets are one of my favorite birds to photograph. They are beautiful, animated, and expressive. If you really need some nature therapy, relax and watch one romp about while fishing. I love that you can hear them clippity-clomping around a salt pond before even catching a glimpse.

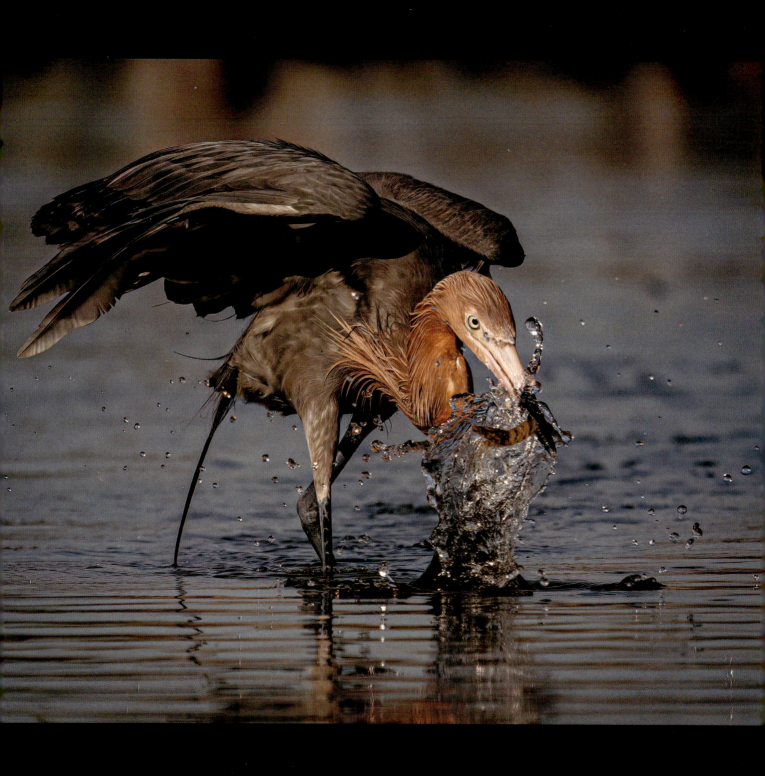

Tortuga Nirvana

Five types of sea turtles swim in the waters of the Florida Keys. These include the more common loggerheads and greens, the less common hawksbills and Kemp's Ridleys, and the even rarer leatherbacks. All are listed as threatened or endangered under the federal Endangered Species Act, meaning we need to take appropriate actions to ensure their future survival.

Turtle nesting season generally runs from April through October. Females crawl onto beaches at night, dig holes in the sand with their flippers, and lay dozens of eggs that take about two months to incubate. They then hatch all at once, like a small volcano spewing hatchlings, who crawl quickly toward the ocean waters using the moon and stars to navigate. Their short journey is fraught with danger. Predators like raccoons, crabs, fish, and birds will all take the opportunity for an easy meal. Still, a few make it to the safety of deeper waters and floating seaweed, though scientists estimate only one in a thousand hatchlings reach adulthood!

I had the opportunity a few years back to join sea turtle researchers who were identifying critical habitats. We boated west of Key West, near the Marquesas Keys, to a lush underwater seagrass pasture frequented by hundreds of green sea turtles. Dozens were surfacing at once. It was a sight to behold. Large pieces of bright green turtle poo were also scattered on the surface waters, indicating just how bountiful this location was.

How to Help

Participate in beach cleanups. Turtles often get sick or die from ingesting trash or being entangled. If you live on or near the beach, limit your use of outdoor lighting during nesting season, since nesting adults and hatchlings can quickly get disoriented and go in the wrong direction. You can also volunteer to do beach nest surveys. Lots of groups need help!

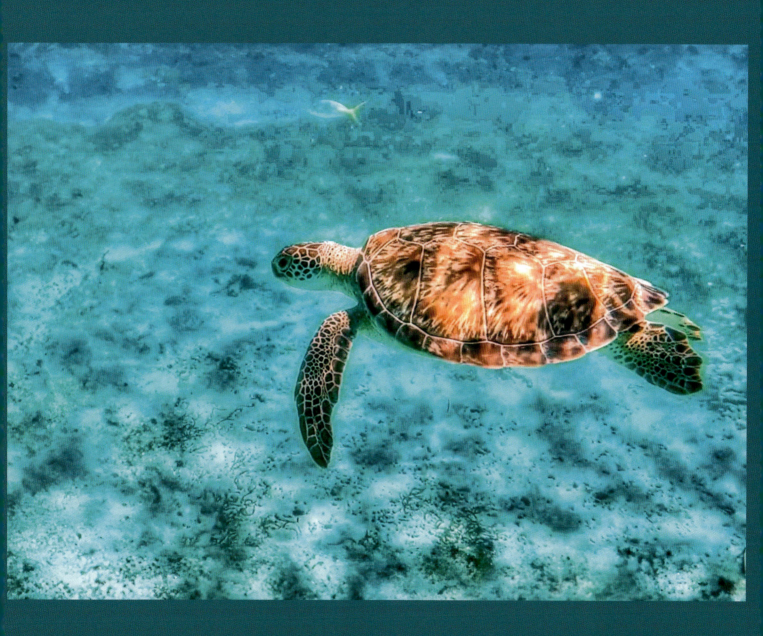

Unsolved Mystery

American kestrels, the smallest North American falcon, overwinter in the Florida Keys. Their sharp call of *klee-klee-klee* resonates through the winter months.

You can find them pretty much anywhere, especially perched on power lines, where they'll scan for and swoop down on unsuspecting prey like insects, small lizards, and snakes. They have bold personalities and will even harass much larger hawks, whom they consider intruders in *their* territories.

One day, several of us observed a kestrel who looked and behaved differently from the typical American kestrel. He seemed a bit lost, and his breast was plain white, instead of spotted. He was also silent, not boisterous like our typical wintering kestrels, as if he were trying not to draw attention to himself.

It isn't unusual for migrating birds to stray off course and show up someplace unexpected. I reached out to some local bird people who thought he might be a CUKE, which is bird biologist speak for Cuban kestrel. Cuba is only 90 miles away, so that was a possibility. A past refuge biologist thought it might be the Southeastern kestrel, a non-migratory subspecies that lives farther up the Florida peninsula, but he wasn't sure. I sent photos to other bird buffs, but never get a conclusive ID. To this day, he remains an enigma.

The mystery kestrel stayed for a few days, feeding on dragonflies and Cuban anole lizards. He'd rest on a short buttonwood tree snag, survey the scene, then swoop down and return to the perch to eat. Then, as abruptly as he had appeared, he was gone, reminding us it matters not what we call him, but more so the memories he left us with.

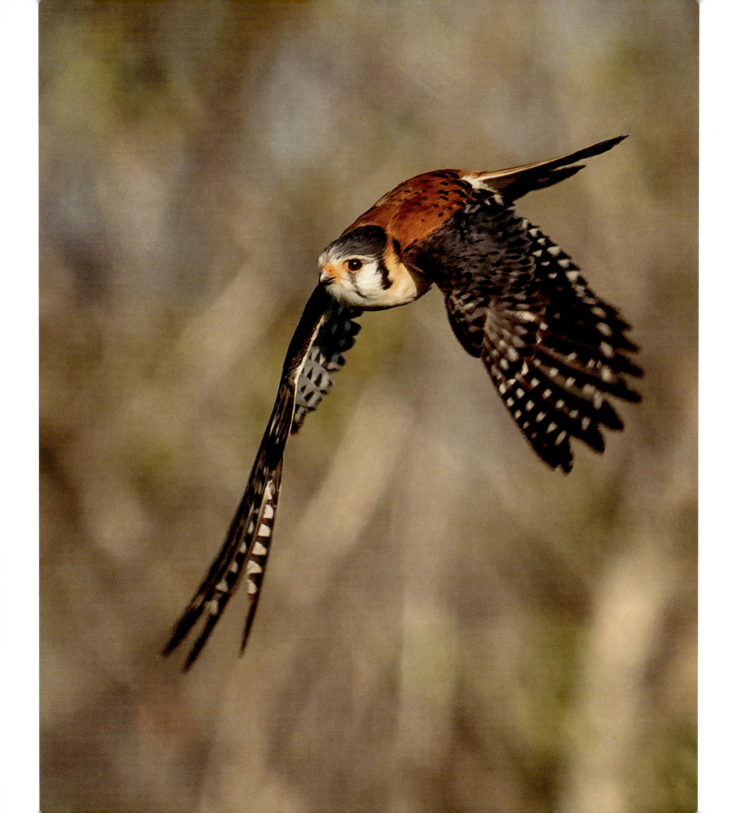

A Cosmic Wilderness

The Florida Keys are the perfect place to experience stargazing and night sky photography. While you can see planets, stars, and galaxies with the naked eye, getting closer with binoculars, telescopes, and cameras brings even more awe-inspiring views. Look for astronomers hosting evening star programs around the Keys during winter, when clear dark skies provide breathtaking views of celestial beauty.

The Keys' southern exposure allows for terrific perspectives of the Milky Way rising above the ocean. One area I am particularly fond of for night sky photography is around the old Bahia Honda bridge. Part of the original Henry Flagler Overseas Railroad, it makes a unique foreground focal point.

A group of photo buff friends hosted a monthly challenge, and one topic was night photography. I wanted to capture the Milky Way, although it wasn't rising until about 2 a.m. Ugh! I dragged myself out of bed, thinking, "This is crazy!" and made the 20-minute drive to the bridge. When I arrived, another photographer was taking photos. He had driven five hours from the mainland to witness our spectacular dark skies! Here's my shot; you can see a little mini-me in the photo. I couldn't believe my remote shutter worked that far away.

Photo Tip

Use a tripod and a wide-angle lens. Some newer cell phone cameras work well, too. A photography app can tell you when you'll see the Milky Way's galactic core. Set your shutter speed to around 20 to 25 seconds to maximize the light. Any longer than that and the Earth's rotation will make the stars appear blurry. Also, review night sky photography techniques before you visit to prevent fumbling around in the dark.

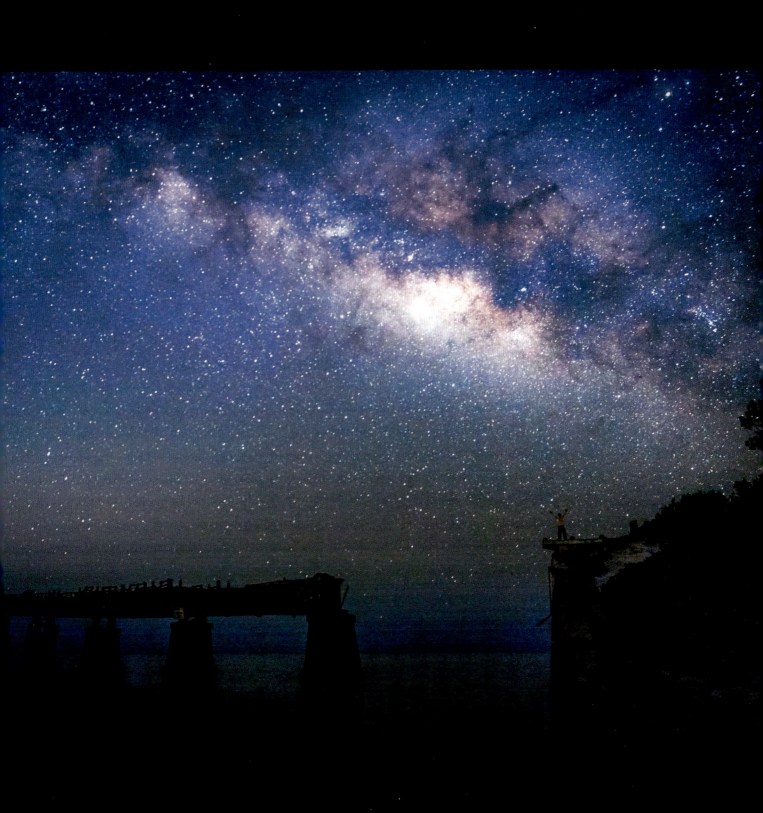

Connections in Nature

Ants and other insects play many essential roles in the world's ecosystems. They are so small that their activities often go unnoticed, but make no mistake, we'd be in a world of trouble without them.

A couple interesting ant relationships found in the Florida Keys include:

Ants helping plants: The Bahama senna is a native shrub with dark-green leaves and bold yellow flowers. At least three species of sulfur butterflies use it as a host plant, depositing eggs which hatch into caterpillars, who then munch away at the fresh buds and flowers. To combat this, the plant solicits the help of carpenter ants, offering them a sugary snack from the base of its leaves. In return for this generous offering, the ants keep the caterpillars at bay.

Ants helping butterflies: Scientists at the University of Florida recently documented that after hatching, endangered Miami blue butterfly caterpillars do something truly remarkable to protect themselves from predators. Their bodies have a small portal that distributes a sugary snack to ants. In exchange, the ants act as bodyguards for the defenseless caterpillars, protecting them from being eaten.

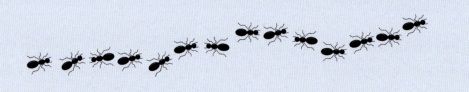

I was looking around for some subjects for macro photography when I noticed a group of carpenter ants going about their workday. I wondered what would happen if I added a water droplet to some dry branches nearby. Several stopped for a sip. A Spanish needle wildflower provided the colorful backdrop.

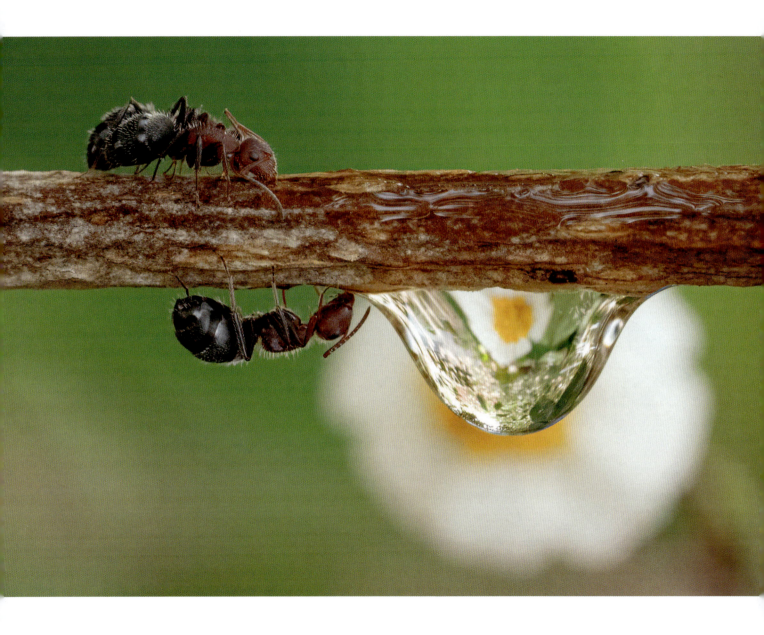

Cracklin' Rosy

This young red rat snake was in a bit of a predicament at the Nature Center one morning. She was tiny, small enough to fit on a quarter, coiled in a defensive posture under a wooden bench. I noticed a curly-tailed lizard nearby, threatening her. Not willing to take a chance that this little one would become a victim of the larger non-native reptile, I gently lifted her and placed her underneath a log nearby in the woods. Her crackly appearance is because she was busy shedding her skin (molting).

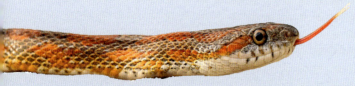

The Keys host at least eleven species of native snakes. There are a few venomous ones, like coral snakes and eastern diamondback rattlesnakes, but those are rare.

One of the more common snakes in the Keys is the red, or rosy, rat snake. They grow to four feet, with brilliant red and orange colors, and are great climbers, so you might find them in a tree or wrapped around your porch railing at night. Red rat snakes are harmless, with no venom or toxins. They are great for pest control, eating rats, mice, lizards, and sometimes birds and bird eggs. If you see one around your home, let it move along; they prefer hiding in dark, protected areas.

How to Help

Most snakes in the Florida Keys are harmless. If you come across one, give it a few moments to compose itself and it will gladly leave the scene. Also, be on the lookout for snakes warming themselves on roads. A gentle tap on the tail will get it moving along (except don't try that for rattlesnakes, for obvious reasons!).

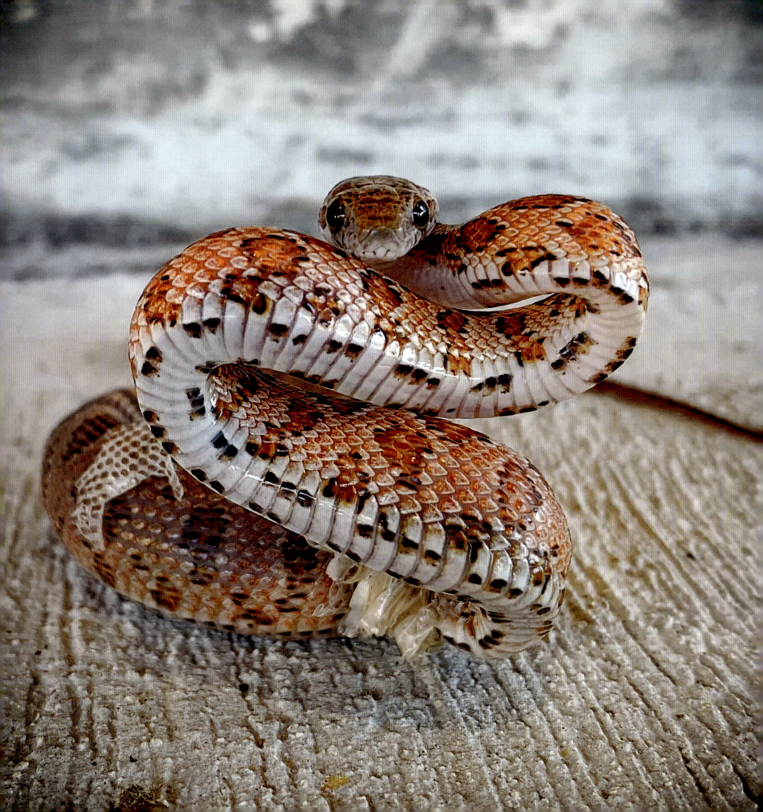

Spoonbill Smiles

I was responsible for the Florida Keys National Wildlife Refuge's Facebook page for many years, where I'd use my photographs to educate the general public about nature-oriented happenings. Occasionally, I'd post a photo and ask folks to have fun by submitting a quip or comment.

When I posted this photo of a trifecta of wading birds — a roseate spoonbill, a tricolored heron, and a reddish egret — gathered at an inland salt pond, I started the ball rolling with, "A spoonbill, egret, and heron walk into a (sand) bar..."

I then asked folks to comment on the punch line. My favorite response was:

"A short-billed dowitcher asks, 'Why the long faces?'"

This still makes me laugh years later. And if you know birds, you know that the dowitchers' bill isn't that short, either, but that's neither here nor there. It served as a nice segue into discussing wetland dynamics during the dry season. As water evaporates, small fish, shrimp, and crabs pack into smaller areas, making them easier for hungry wading birds to catch.

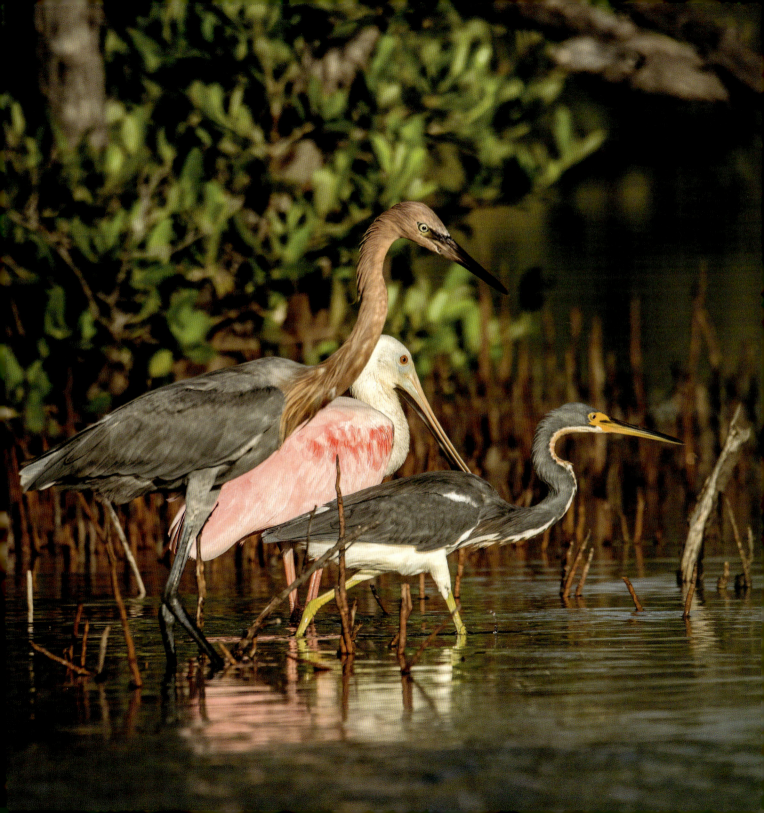

Spring *Wildflower Season*

A subtle, yet perceivable change occurs as winter transitions into spring. The dry season comes to an end. Clouds reappear with consistency. Life-sustaining rains fall from the skies.

Although flowers in the Florida Keys bloom year-round, this is the primary wildflower season. You'll find all of the colors of the rainbow out there, from pinks and reds to blues, purples, greens, yellows, and whites.

In his book *Florida Keys Wildflowers*, botanist Roger Hammer states that at least 871 plant species are native to or naturalized in the Keys. That's some major biodiversity! And most interesting is that the flora more resembles that of the Bahamas, Cuba, and coastal Yucatan versus mainland Florida. So how's that? Migratory birds, winds, currents, and tropical storms all help carry tropical seeds and propagules to our shores where they find hospitable conditions for growth.

Marsh pinks (right) are a favorite of mine. Find them in pine rockland habitat, adjacent to freshwater wetlands, and even in shallow roadside depressions with moist soil that holds water after it rains.

Where to See Them
To view native wildflowers in bloom, visit the national wildlife refuges, parks, and botanical gardens throughout the Florida Keys. My favorite places are the Watson and Mannillo Trails on Big Pine Key, which are part of the National Key Deer Refuge, and the Key West Tropical Forest & Botanical Garden on Stock Island.

How to Help
Never pick wildflowers. Instead, take a photo to remember them. Let them be wild and free, available for the next person or pollinator to appreciate.

Marvels of Migration

Can you hear them? Little squeaks and whistles in the sky. Thousands of small songbirds land quietly at dawn, stopping for a few days to rest and refuel. It's the annual spring migration from southern wintering grounds to northern breeding grounds, and they've been traveling all night, navigating by the stars, moon, and the Earth's magnetic field. For some, the journey may be a few hundred miles. For others, it's thousands.

During this time, the warblers — like this male common yellowthroat — are decked out in their breeding colors. Once they return home, they'll sing their hearts out to attract a mate and defend their territory. But here in the Keys, you won't hear a peep. Here they are strangers in a strange land. No need to draw attention to themselves. They are tired, and predatory birds are migrating north with them. Best to focus on finding food, water, and some rest. Many perilous miles lie ahead.

Sometimes I follow the birds north to escape the heat of Florida summers. Recently, I was out on a walk in Nova Scotia, some 2,000-plus miles from the Florida Keys, when I heard a familiar song. Wichety-wichety-wichety. I stopped and waited; someone was watching me.

After a few seconds, I smiled at a familiar masked man. A common yellowthroat zipped down to give me a closer look. I wondered if he was one of the many who had stopped over for a brief respite in the Keys, and marveled that a creature who could easily fit in the palm of my hand could undergo such an amazing long-distance journey.

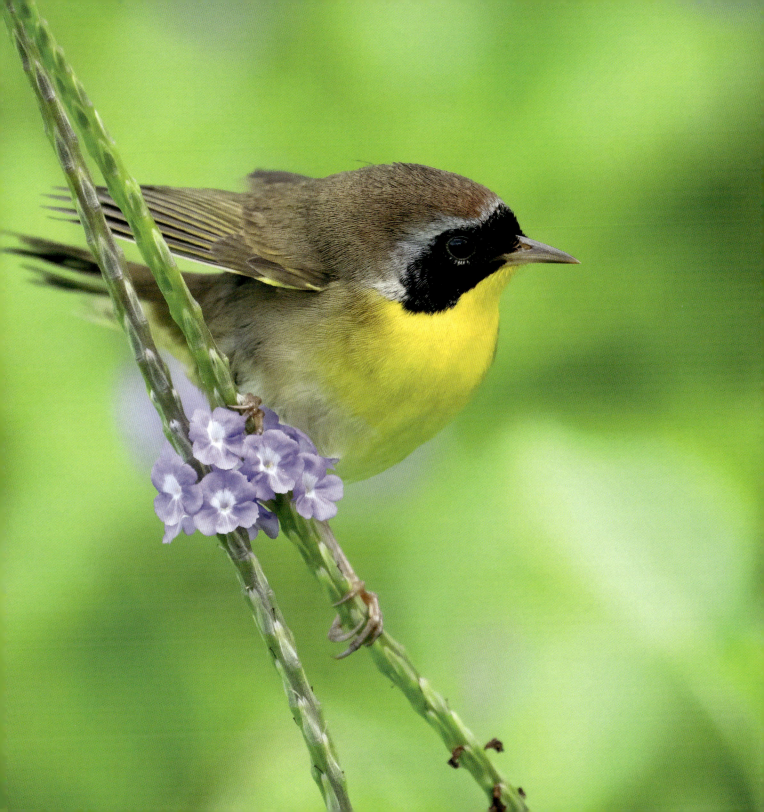

Perfect Timing

Did you know that the spring bird migration is timed to coincide with peak food availability along the way? Fresh blooms and plant foliage help birds survive the long journey to their breeding grounds. They host a multitude of insects and juicy caterpillars, who in turn become meals for hungry warblers, tanagers, buntings, and other travelers. Others, like hummingbirds, take advantage of the nectar produced by flowers to fuel their migration.

A few ruby-throated hummingbirds overwinter in the Florida Keys. However, most travel to Central America, where it is consistently warm, and nectar-providing flowers are abundant. We see them for just a few days in April or May, when they stop to rest and refuel before moving onwards to breeding grounds in much of the eastern US and Canada.

You just might hear a hummingbird before you see one. Their quick wingbeats sound insect-like as they buzz past. You may also hear them talking among themselves with little chirps and squeaks. We were lucky enough to host a female ruby-throated hummingbird when we moved to the Keys. She entertained us for three winters before disappearing. Now I look forward to springtime when our flowering native plants, like Jamaica dogwood and Jamaica caper, attract others to our back yard for several days, offering leisurely photography opportunities.

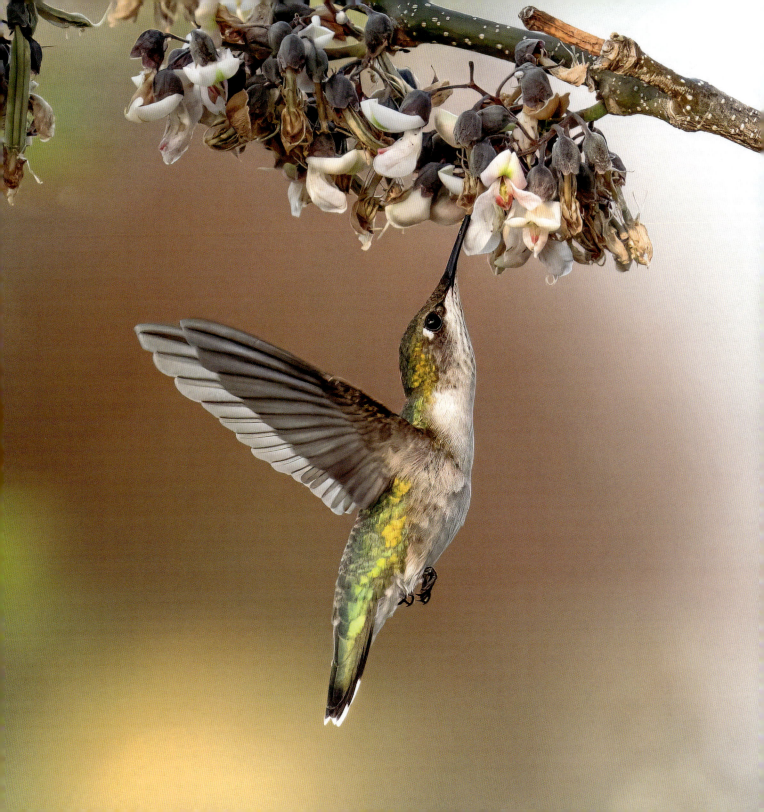

Nature's Mood Rings

Green anoles live throughout the southeast, and are the only species of anole native to the US. In the Keys they aren't the easiest creatures to locate. Recent research suggests they have become more arboreal over time, hanging out higher in trees versus on the ground, to avoid confrontations with the more aggressive non-native Cuban brown anoles who have invaded their habitats. Up in the trees is usually where I see them, too.

Green anoles can be conspicuous when they want, with fluorescent lime-green scaly skin and a hint of turquoise eyeliner. Their flashy red-and-white dewlap acts as a social display, which they extend and retract while bobbing their heads to attract ladies or proclaim territories. But if they're frightened or wishing to remain incognito, they quickly turn dull brown to camouflage themselves.

They remind me of those '70s fad mood rings, which supposedly turned bright when someone was happy and darker when they were sad. Here's how to decode green anole's moods:

Bright green = happy, look-at-me mood.

Brown = incognito, sullen, or chilled.

I still hadn't gotten a picture of a green anole that I was ecstatic about. Whenever I spotted one, in the few seconds it took to raise my camera and focus, it had already jumped away and turned brown, all in one fell swoop. I was lamenting this fact on my Facebook page one week when the following happened... (see next page)...

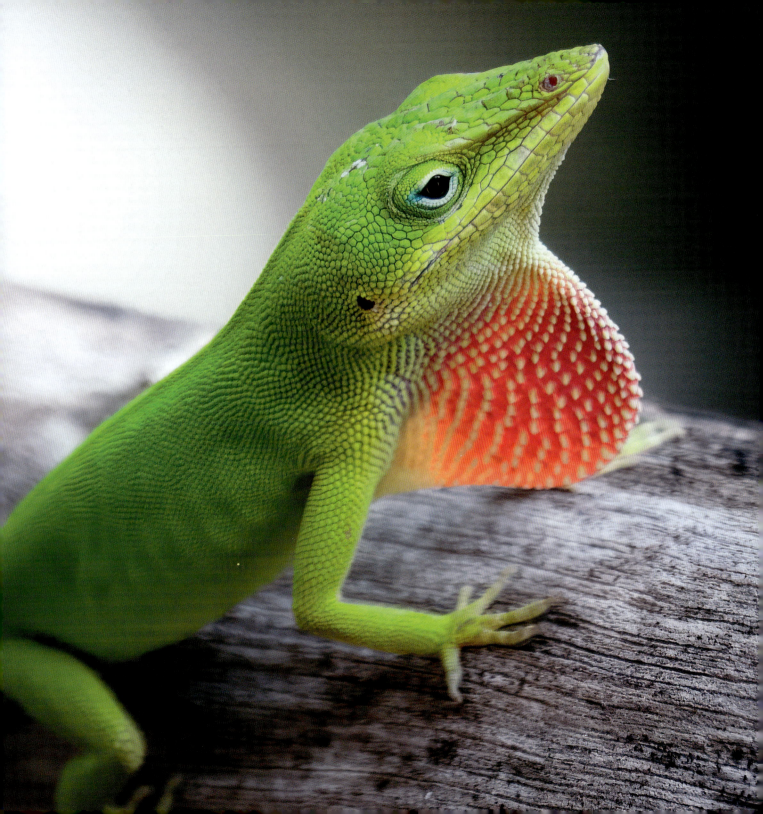

Do you see what I see? Look!

I was excited to witness this male ruby-throated hummingbird nectaring in our Jamaica dogwood blossoms one spring morning. He was flitting back and forth in one spot, allowing me to take dozens of photos from the comfort of my back porch.

Surprisingly, when I went to my computer to review the images, I realized he wasn't feeding; he was inspecting a green anole perched on a branch. He was so persistent that the anole eventually became a more camouflaged brown to blend in with the tree bark.

Photographs like this make me wonder how much of the nuances of nature's interactions go unnoticed without the luxury of closer inspection. Most likely, he was making sure the anole wasn't a predator to be concerned about, but I'd like to think he was shouting at me, look here, Kristie, I've found you that green anole you were looking for!!

How To Help

One of the easiest ways to support wildlife is to create native habitats in your yard and your community. Native plants are essential to supporting the food chain and web of life.

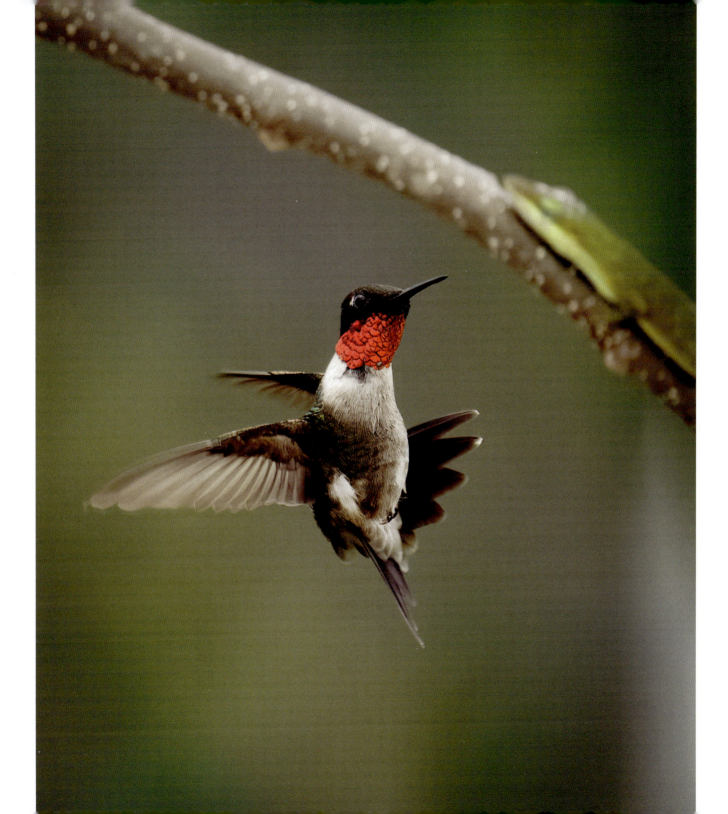

Here Be Giants

Spring marks the return of one of our largest fish, the Atlantic tarpon, or silver kings, as some call them. Tarpon can get huge, up to eight feet long and over 250 pounds. Strong, wary, and powerful, they are a favorite of recreational fishermen, and primarily a catch-and-release species.

There is a calm peace amongst Atlantic tarpon as they rest gently facing the tide. I'm struck by a feeling of absolute awe when surrounded by a school, all larger than me, circling or streaking by slowly, one by one, giving me a once-over acknowledgment. It's a sense of swimming with old souls — and with these giants, who are capable of living more than 50 years — you are indeed amongst seasoned beings. The old-schoolers in this photo were under the Bahia Honda Bridge.

I've always had a thing for fishes. I even did my master's degree research on them. I used to be an avid fisherman as well, but lately I've come to appreciate their elegance from an underwater perspective. I feel completely at peace floating while watching them go about their daily lives.

Some of my favorite places to explore are under the many bridges that connect the islands of the Keys. Their structure and shading provide a habitat for fish, lobsters, and various other sea creatures. These bridges aren't easy to visit; one has to be very conscious of the tides, with slack tide lasting 30 minutes or less. Once you feel the pull of the currents, it's time to get out and return this shadowy realm to those better equipped for the task.

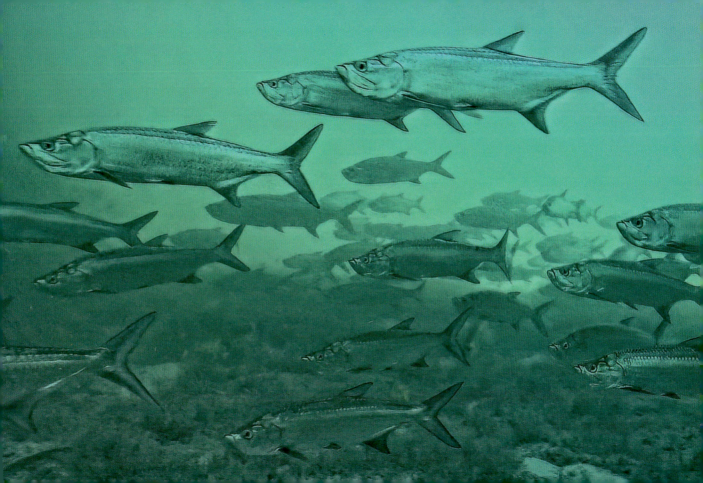

Spotted Treasure

April is the official start of the Key deer fawning season. It peaks in late spring and early summer, but sometimes even includes late-fall births.

There is no stronger bond in nature than that between a mother and her child. The Key deer is no exception. Key deer moms (does) teach their fawns the lessons they need to survive in a sometimes-harsh world — what to eat, where to find food and water, where to rest, and whom to trust. They'll stick together throughout much of their first year, and sometimes for years into the future.

This tiny Key deer fawn is one of the smallest I've ever seen. She was living in my neighborhood, and I nicknamed her Itty Bitty. She was no larger than a house cat.

One afternoon she was searching for Mom everywhere. She appeared frightened and distraught. She was busy calling out when Mom appeared. She went charging up and immediately began nursing. Once reunited with the safety and security of her mother, her worries melted away instantly.

How to Help

If you are lucky enough to see fawns, please just appreciate them from afar. Do not approach them or interact with them during this critical period of maternal bonding and care. Mothers commonly leave their newborn fawns alone for long periods, sometimes up to twelve hours. This does not mean the fawn has been abandoned or orphaned, but rather it's a strategy to protect the youngster from predators since they cannot keep up with their mother.

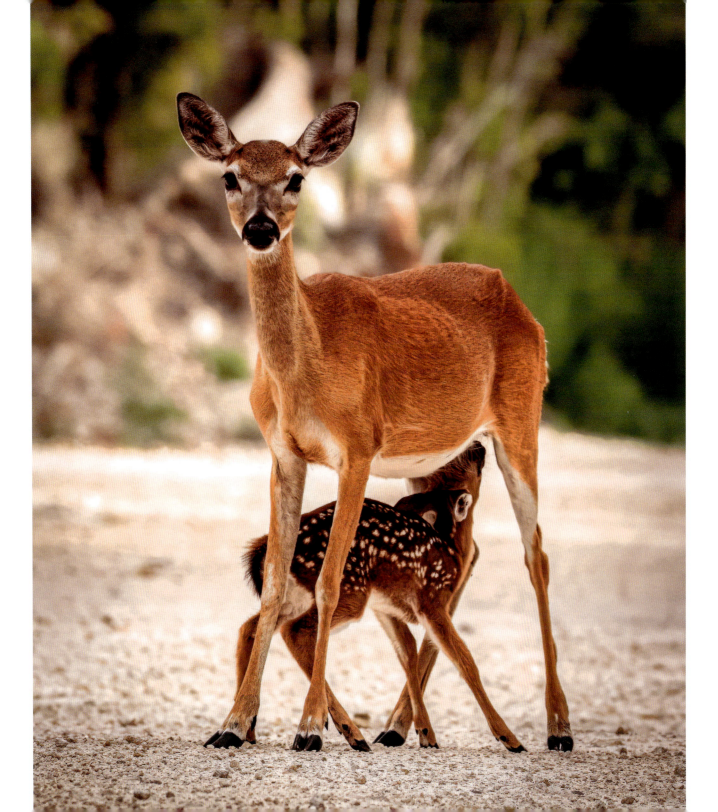

Mosquito Control

Dragonflies and damselflies are nature's natural mosquito control. According to the Florida Extension Service, the state is home to more than 150 species of Odonata (dragonflies and damselflies). Several of those live in the Florida Keys, although there is much less diversity here since freshwater wetlands, which are essential for their life cycle, are limited.

Adult dragonflies eat hundreds of mosquitoes and small flying insects each day, helping to keep those populations under control. Dragonflies mate in flight, and females lay their eggs in freshwater wetlands. Once the eggs hatch, dragonfly larvae, called nymphs (or naiads), begin an aquatic lifestyle.

Nymphs are tiny but voracious predators, feeding on mosquito larvae, beetles, tadpoles, and small fishes. When it comes time for a final molt into adulthood, they'll climb into the air on a stick or piece of grass and emerge.

This Halloween pennant dragonfly was living up to its name, sporting orange-shaded wings with brown bands, and perching at the end of a twig blowing in the wind, looking like a flag or pennant. These dragonflies aren't intimidated by strong winds or cool temperatures. They are found year-round in Florida, and range throughout the east and central US.

How to Help

Avoid using insecticides. They are often harmful to all insects, including dragonflies.

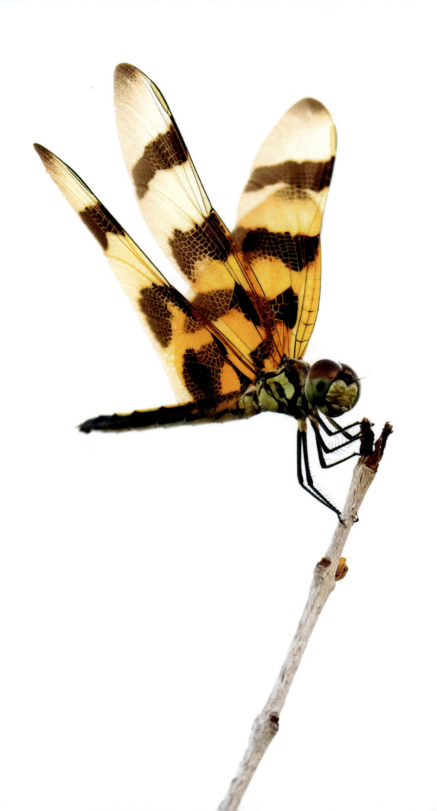

Faithful Beauty & A Modest Host

My neighbors have a wonderful Pisonia tree, which I can view from my back porch. Pisonias are so inconspicuous, with such unremarkable flowers, that people haven't even given them a proper common name. Instead, they go by their scientific name *Pisonia rotundata*. Well, shame on us for neglecting to appreciate this incredible little tree! It comes to life in the springtime, putting out thousands of little green flowers and attracting bees, butterflies, moths, and other pollinators. Migrating warblers and other songbirds visit, looking for a meal of small insects and caterpillars.

I was watching the birds in the Pisonia one morning when an iridescent, fast-flying insect caught my attention. I was pleasantly surprised to finally meet the faithful beauty moth! While most moths are nocturnal, and nearly all butterflies fly during the day, exceptions exist, including faithful beauties. Their contrasting red, white, and blue colors pop against a black background, making them hard to miss. They aren't common in the Florida Keys, but you might get lucky, especially in the spring when flowers bloom.

A Fun Activity

Look for educational programs by *Keys Moths*, where they use nighttime light stations to attract a dazzling array of moths and other nocturnal visitors. Dozens of new moth species have been discovered this way. It's a great program, filled with heartwarming stories, and perfect for both kids and adults.

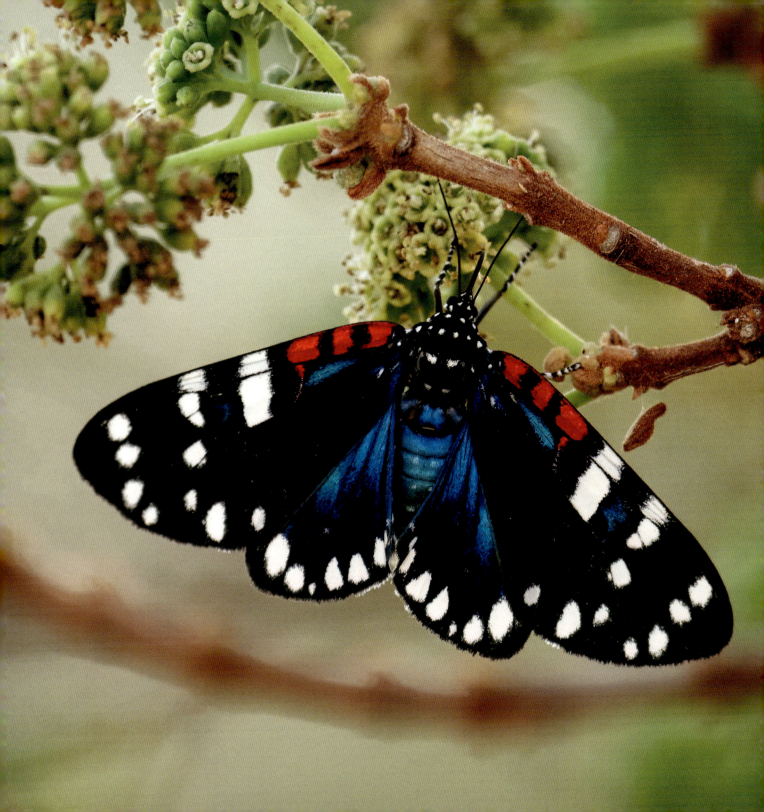

A Giving Tree

My bedroom window overlooks a large gumbo limbo tree. In the spring, I take the screen out and use the window frame as a camera perch. It offers a relaxed setting to enjoy the marvels of nature. This male rose-breasted grosbeak had stopped over for a few days to rest and refuel on gumbo limbo berries. He was a long-distance traveler, wintering in Cuba, the Caribbean, or Central and South America. When I saw him, he was headed to breeding grounds in the northern US or Canada. Having safe and productive habitats along the way, like this gumbo limbo, is critical to his survival.

The gumbo limbo: if there ever was a tree that meets the definition of a giving tree, this is it. Their fruits ripen and fresh leaves emerge just in time for spring migration, feeding dozens of migratory birds and residents like red-bellied woodpeckers, mockingbirds, and cardinals. Some birds eat the fruits, while others eat little caterpillars feasting on the tree's new leaves. Below the tree, Key deer and raccoons gobble up the fallen fruits.

Gumbo limbos are perfectly adapted to tropical island living. They resist hurricane winds by choosing to shed their branches, so they don't blow over. They are also easy to plant. All you need to do is take a branch, plant it in the ground, and keep it watered until it's established. Voilà! Backyard habitat. Leave plenty of space for it to grow, since they create a broad canopy and reach thirty to forty feet tall.

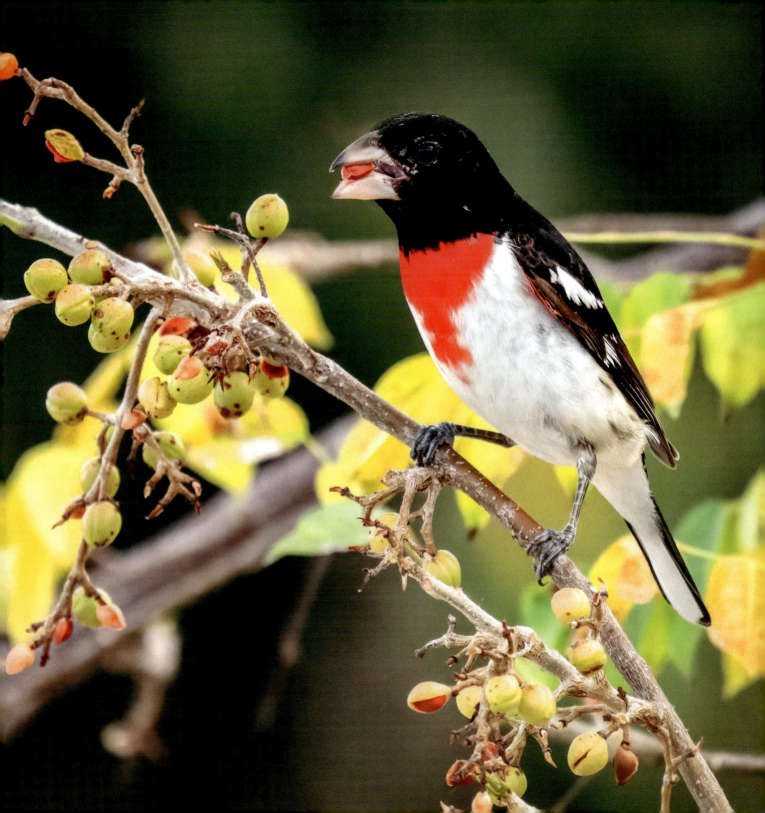

Summer *Endless*

Bring on the heat! Air temperatures rest in the 80s and 90s all summer. Winds are calm and warm out of the tropical southeast. Our avian and human snowbirds have headed north to enjoy cooler climates, while many of our summer resident birds raise their young. Key deer fawns grow and learn from their mothers. Alligator, crocodile, and sea turtle eggs incubate in nests. Forest dwellers, like tree snails, enjoy the humidity, and butterfly orchids bloom.

I love summers, but in the Florida Keys they can be brutal if you aren't prepared. You must adapt your outdoor adventures accordingly. My feet vehemently protest the idea of socks and shoes; summer footwear includes water sandals, flip-flops, and swim fins.

One of my neighbors used to say, "You have to live like you are on vacation." I always thought that was a great mindset. So, take your walks at sunrise or sunset to avoid the day's heat. Get out and enjoy a shaded walk in the woods. And cast off those lines and get out on the ocean! Calm winds and warm waters make for the most fabulous boating and saltwater explorations, both over and underseas.

Woodpeckers love to nest in dead tree snags. They'll use their bills like a pickaxe to create an inner nest cavity. Red-bellied woodpeckers are year-round residents of the Florida Keys. They have a crazy habit of knocking loudly on metal gutters to establish territories and attract mates. Here, an adult male feeds his fledgling a tidbit pulled from a decaying tree; soon, the youngster will be on his own.

Underwater Therapy

As waters warm and winds subside, it becomes easier to visit the undersea world of the Florida Keys barrier reef. One of my favorite places to snorkel is the Looe Key Reef area, which is a 45-minute run by boat from our house. I often moor on the back reef, as it's a little more protected from waves. This part of the reef also lies adjacent to seagrass meadows, home to parrotfish, hogfish, queen conch, sea turtles, and more. It's like being immersed in an underwater movie that unfolds frame by frame in living colors.

Blue tangs tend to travel over the shallow areas of the reef in large groups. They are herbivorous, mainly grazing on algae. Like many reef fish, youngsters look different from adults. Juveniles are a bright yellow color; they'll gradually change to all blue as they age. Their blues can change, too, with lighter and darker hues.

If you don't have your own boat, there are dozens of ecotours to the reefs and other nearshore areas. Check the Florida Keys National Marine Sanctuary's Blue Star charter list to find one committed to coral reef conservation and education.

How To Help

Visit gently. Use reef-safe sunscreen — better yet, wear UV-safe swimwear instead. Don't touch or stand on any part of the reef ecosystem. And beyond your visit, advocate for and support actions to save reefs and stem global warming. The reefs are struggling from diseases and coral bleaching due to higher water temperatures from climate change.

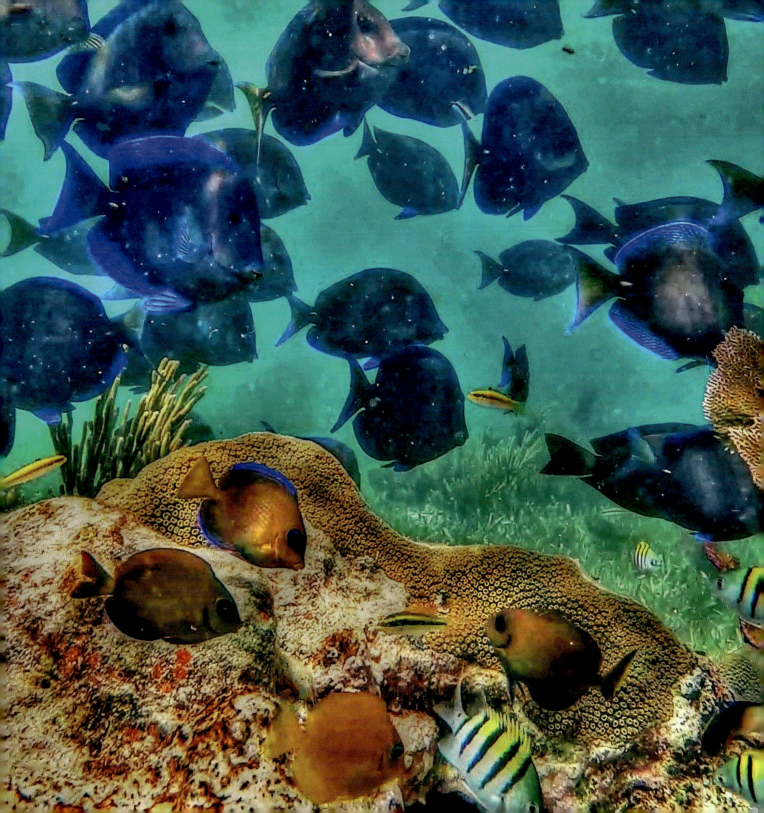

The One Less Traveled By

As summer sinks in and air temperatures rise into the 90s for weeks, I seek shelter in the shadows of the hardwood hammock habitats. I often ramble around the woods near my house, looking for plants and animals who enjoy the darker, shady side of the Florida Keys. I liked how this gumbo limbo's bark was illuminated by the sunlight, with the little starburst effect from the sun shining through the leaves. They call gumbo limbos the "tourist tree" because their red, scaly bark is reminiscent of the peeling skin of visitors who get a little too much sunshine.

The hardwood hammocks, where the gumbo limbos live, are the domain of large orb weaver spiders. They often set their webs across open, sunny trails, so be on the lookout or you might end up wearing one! They are fastidious about keeping their webs clean from debris. To highlight this, a biologist friend once threw a small stick into an orb weaver's web. Immediately, the spider went over, grabbed the stick, unraveled it, and tossed it to the ground. Then, I'm pretty sure she gave us both the stink eye.

Hardwood hammocks grow on the highest ground. Here in the Keys, that means one to two meters above sea level — so don't worry, you won't suffer altitude sickness as you stroll along! But be wary, as mosquitoes may have multiplied into a thundering herd. Once you step inside the woods, you'll know if that is the situation quickly enough.

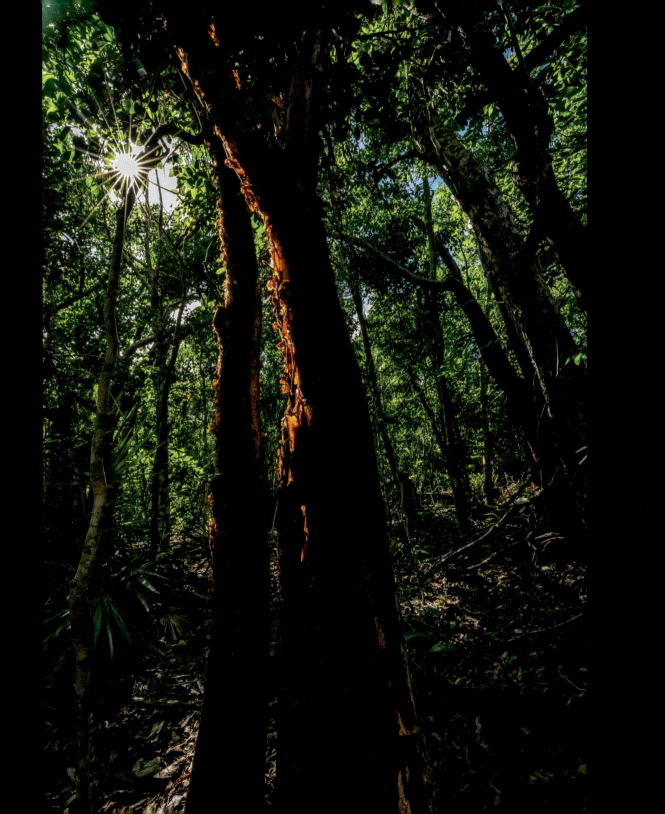

Hitchhiker

I ventured into the woods one day to look for tree snails. I wandered around for an hour, brushing through the leaves of smaller trees, with eyes directed upward. I saw several crawling around high up. When I popped out to the road to end my adventure, I felt something gooey on my face. I gently took off my sunglasses and discovered this little hitchhiker. I left him on a nearby tree to continue his and her journey (tree snails are hermaphrodites).

We have at least five species of tree snails who reside in the Florida Keys. The most common, the Florida tree snail, has more than fifty named color varieties. Some are strikingly beautiful, while others prefer to remain a little more inconspicuous with muted and camouflaged colors.

Tree snails are arboreal, spending their lives on the bark and branches of trees, and only venturing to the ground to lay their eggs. They are most active during the wet season, using their rasping tongue to graze on algae, fungi, and lichens from trees within the hardwood hammocks. They prefer smooth-barked trees because… who needs speed bumps? Once dry winter conditions arrive, the snails hunker down in a state of inactivity like hibernation, called aestivation.

How To Help
It's against the law to collect tree snails and their shells. Please appreciate them from afar.

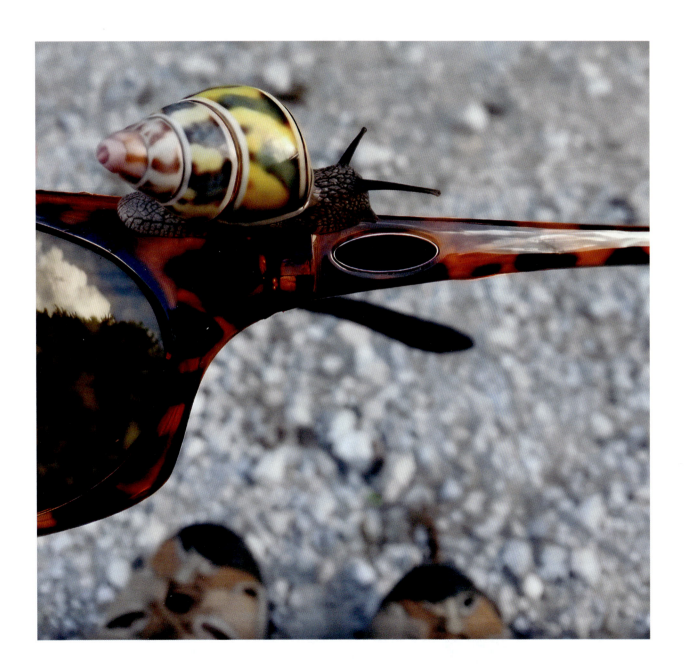

Housing Crisis

The land hermit crab found in the Florida Keys has several common names, including the Caribbean hermit crab, tree crab (they can climb trees), or my favorite, the purple pincher! Yes, given the opportunity, they'll give you a little squeeze, so try not to offend one. Hermit crabs hang out where the land meets the sea, just upland of the mangrove shorelines, amongst the leaf litter.

Hermit crabs are omnivorous scavengers, eating all sorts of plant and animal materials. They lack a hard protective shell, having evolved to use snail (gastropod) shells for shelter. They must upsize those homes as they molt and become larger, sometimes trying on various ones before finding that perfect fit. Sometimes they'll even gather with friends to hold home exchange parties.

I was sitting on my upstairs porch, mulling over how to compose the tree snail story on the previous page, when a subtle movement on the ground caught my eye. I went downstairs to investigate and was surprised to see a land hermit crab, using a shell of a Stock Island tree snail for protection — providing a perfect segue into this story!

How to Help

When out shelling, leave behind shells that could be of use to hermit crabs. Worldwide, hermit crabs have experienced shell shortages due to our over-collecting of shells. In need of shelter, some resort to using trash like toothpaste lids or small bottles. If you have a box of shells collecting dust in your attic, sprinkle some around in crab country. They'll put them to good use.

Summer Beauty

The Florida butterfly orchid is native to South Florida and the Florida Keys. It is an epiphyte, growing without soil, on branches and trunks of trees. Butterfly orchids bloom during summer when the tropical hardwood hammock is moist and humid. They provide a welcome splash of color to the typical greens and browns of the forest community.

If you are lucky enough to see one while walking in the woods, please leave it for the next person to enjoy, as this species is imperiled due to illegal collecting.

I asked the Palm Vista Nursing Home Poetry Guild if they'd assist with creating a poem to honor the native butterfly orchid and other Florida Keys flowers. Here is what they came up with:

The Power of the Flower

Hummingbird buzzing around
Beautiful pink
Sweet smell like frangipani
A sneeze echoes nearby
A women's perfume turns a man's eye
Hummingbird wings flapping fast
Above black dirt
And green green grass
Bugs with brightly colored wings
Big Big Big
Climbing on the Orchid's twig

— *Courtesy Palm Vista Poetry Guild,*
September 2023, Key West, Florida

Thanks to Vicki Grace Boguszewski, the Poet, Jah Love,
of the Key West Poetry Guild, for facilitating.

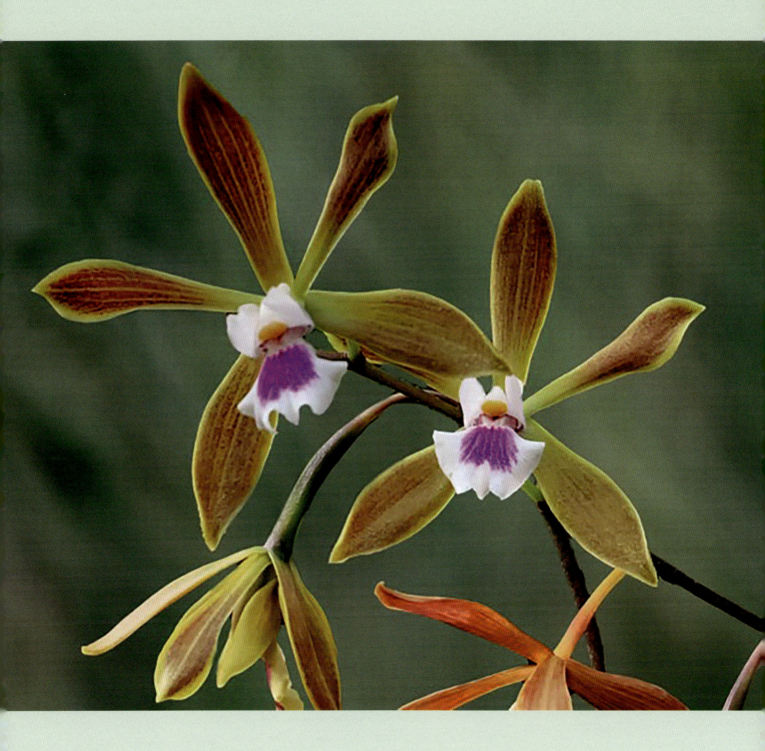

Give a Smidgen for the White-Crowned Pigeon

White-crowned pigeons live here during spring and summer. Like human parents, they make sacrifices to ensure their young are raised in a safe place. That means nesting on backcountry mangrove islands where there are few snakes, raccoons, or feral cats. Unfortunately for the pigeons, there is also little to eat out there, so they take shifts on the nest while the other parent flies inland for a meal. This daily commute can be as long as ten or twenty miles each way.

White-crowned pigeons are frugivores, eating the fruit of trees including fig, blolly, seagrape, and pigeon plum. Then the hard seeds are dispersed via their scat to start new trees elsewhere. Poisonwood, a tree that can make humans itchy and scratchy, is one of their favorites. They gobble up the fruits to make crop milk, a milky liquid filled with nutrients, for their newborns.

I felt privileged to assist a refuge biologist who had set up a live webcam on a white-crowned pigeon nest in Great White Heron NWR. It was no easy feat, requiring solar power, MacGyver-esque skills, and a giant antenna, which she climbed a spindly tree to install. We waited anxiously for the eggs to hatch, and celebrated once they did. Sadly, our festivities were short-lived. A day later a friend texted, "Oh no, what is that? Look at the webcam!" A young, red-shouldered hawk was perched on the nest. Himself struggling to survive, he was thankful for finding an easy meal, but created a rather sad ending to our pigeon story.

Hawks aside, the Keys are a respite for white-crowned pigeons, since they are hunted for food in the Caribbean where they spend their winters. Once they get back here, they play an important role in Keys ecology. I credit a biologist friend of mine with the phrase, "Give a smidgen for the white-crowned pigeon."

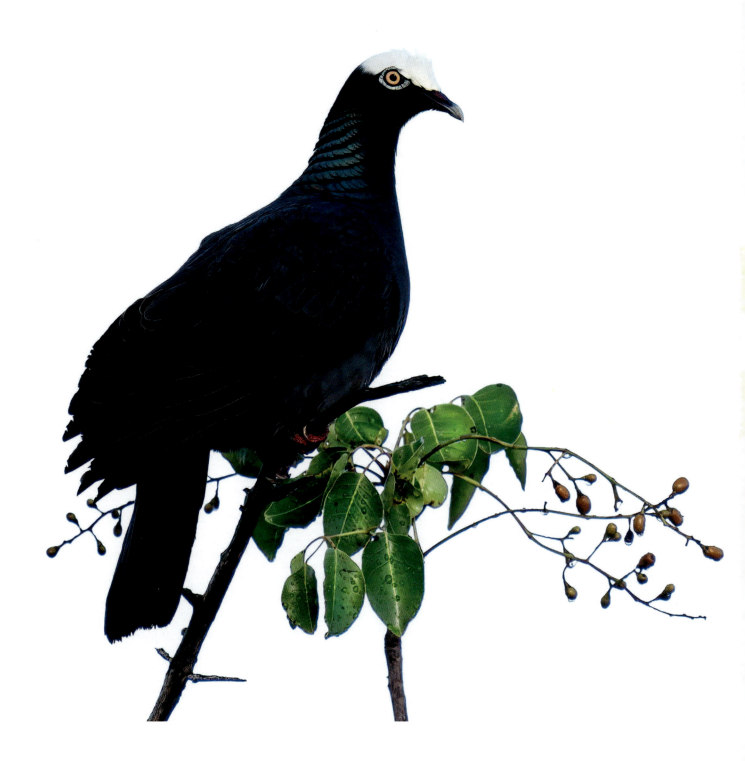

Mangrove Mysteries

No story of nature in the Florida Keys is complete without mentioning endangered Key deer. Found nowhere else in the world, their geographic range is restricted to less than two dozen islands in the Lower Keys, where they walk, wade, and swim to find food, water, and mates. They eat hundreds of native plants, especially enjoying red mangrove leaves, which line the islands' salty edges.

Key deer are the smallest subspecies of white-tailed deer, about the size of a Labrador retriever. They are tiny, but mighty, having survived overhunting during the 1900s, catastrophic hurricanes, and a life lived alongside people.

Refuge biologists once worried that too many Key deer lived on just two islands: Big Pine and No Name Keys. They thought spreading them out more evenly over other islands would better protect them from diseases and hurricanes. So they captured several and brought them to Little Pine Key. The deer had other thoughts, though, and soon jumped back in the water to swim home.

Having learned from these early mistakes, later attempts to translocate animals to Sugarloaf and Cudjoe Keys involved penning the deer for several months to acclimate them to their future homes before release.

Where to Find Them & How to Help

Key deer are year-round residents and travel in all habitats. The best time to see them is at dawn and dusk. Visit the Florida Keys National Wildlife Refuges Nature Center on Big Pine Key for advice. Remember, Key deer are wild animals. Please appreciate them from afar and do not feed or touch them. When we change their behavior, we put them in danger. Celebrate their wild!

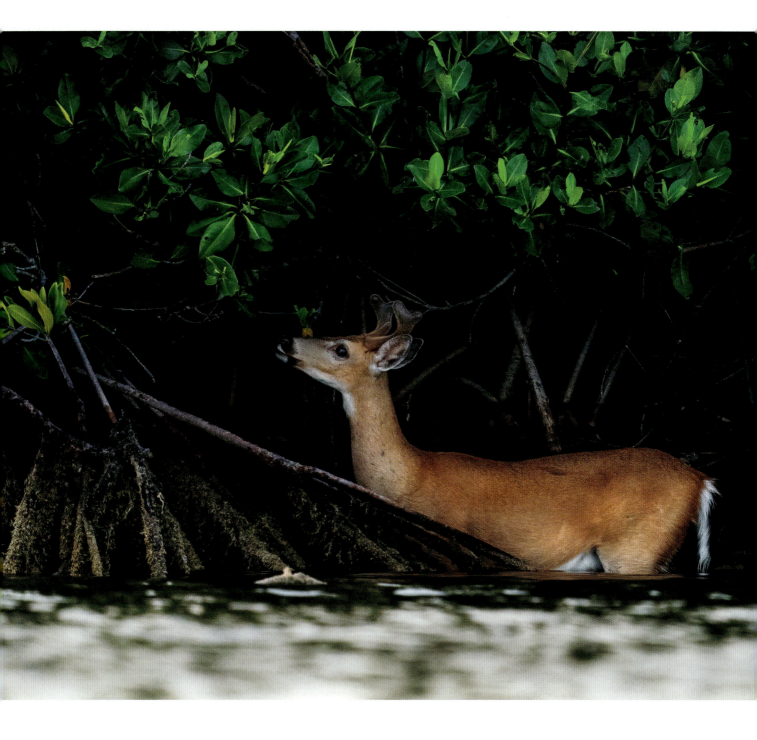

Mangrove Tutu

Previous thinking was that American flamingos in the wild must be ornamental escapees. But scientists now believe they are true Florida residents at the northernmost extent of their range. Along with herons and egrets, American flamingos were decimated in the early 1900s due to the millinery trade, aka the fashion industry. So it may just be that their numbers here never fully recovered.

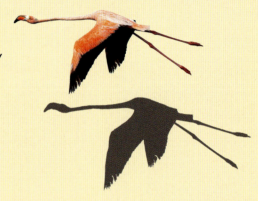

This American flamingo was part of a flamboyance of five flamingos who visited the Florida Keys in Summer 2020. This stunning creature was single-handedly responsible for getting many of us out of our Covid-19 lockdown funk. Nature lovers, photographers, and other curious residents made the pilgrimage to hail its arrival. One Friday evening, there was a grand reunion with dozens of us who hadn't seen each other in two months. It was a wonderful moment, like being back in time at an outdoor drive-in theatre, with the star being a flamingo!

One calm morning, a group of us were at the viewing area when no-see-ums descended with enthusiasm. I tend to overdress in prep for bugs, so after the others packed up and ran, I suddenly found myself alone. I sat down in silence. To my surprise, the flamingo began walking toward me from the back of the marsh. My hands trembled on the camera shutter as the bird circumnavigated a small mangrove, quietly feeding just a few feet away. I took hundreds of photos, but I love this one. Someone said to me, "It looks like he's wearing a ballet tutu." Indeed it does!

Where to Find Them & How to Help

Flamingos are occasional visitors to inland salt ponds and shallow coastal edges. Sometimes, like in 2023, they visit when hurricanes sweep them off course. Consider yourself lucky if you see one, and if you do, use a telephoto lens or binoculars to get close. Boaters, paddle boarders, and kayakers who approach too close cause stress, ultimately resulting in their departure.

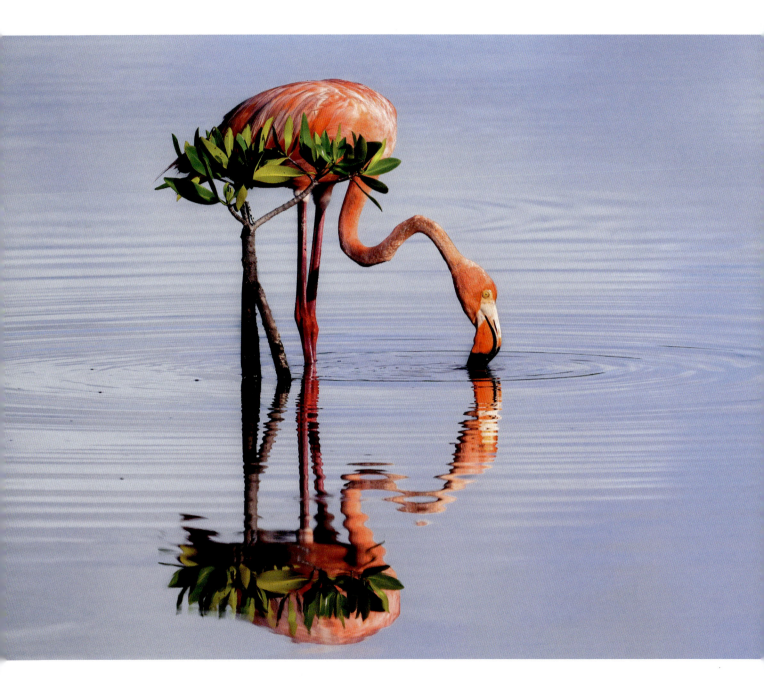

Feisty Fliers

Gray kingbirds are summer residents of the Florida Keys. Like all flycatcher family members, they are bug-control experts. To catch their prey, they perch high in conspicuous locations, swooping in to catch insects mid-air. They'll also eat the fruits of trees like figs, gumbo limbo, and poisonwood. Their feisty disposition is well known, and they often pester other birds just to show them who's the boss.

Once upon a time, a least tern colony spent summers nesting on the rooftop of the Big Pine Key supermarket. Laughing gulls would perch on the opposite building, harassing the terns, who were trying their best to protect their eggs and young.

Simultaneously, gray kingbirds were nesting in mahogany trees in the parking lot. When a gull would fly toward the least tern colony, it would often get blindsided with a swift and stern rebuff from the smaller kingbirds, who were defending their own nests. The gulls would scream with displeasure, quickly returning to their side of the parking lot.

Sadly, the supermarket had to replace its leaking roof with a less-least-tern-friendly one. The mahogany trees were cut down to mitigate water drainage, and the entire little ecosystem gave way to "progress." If you hadn't paid attention, you wouldn't even know that this small piece of nature had quietly disappeared.

In this photo, a gray kingbird had grabbed a large cicada mid-air and was trying to figure out how to swallow such a large catch. He started tapping it on the wire to break it apart. Within a few seconds, a second gray kingbird arrived and tried to steal breakfast. After some high-wire acrobatics, the rightful owner secured his meal.

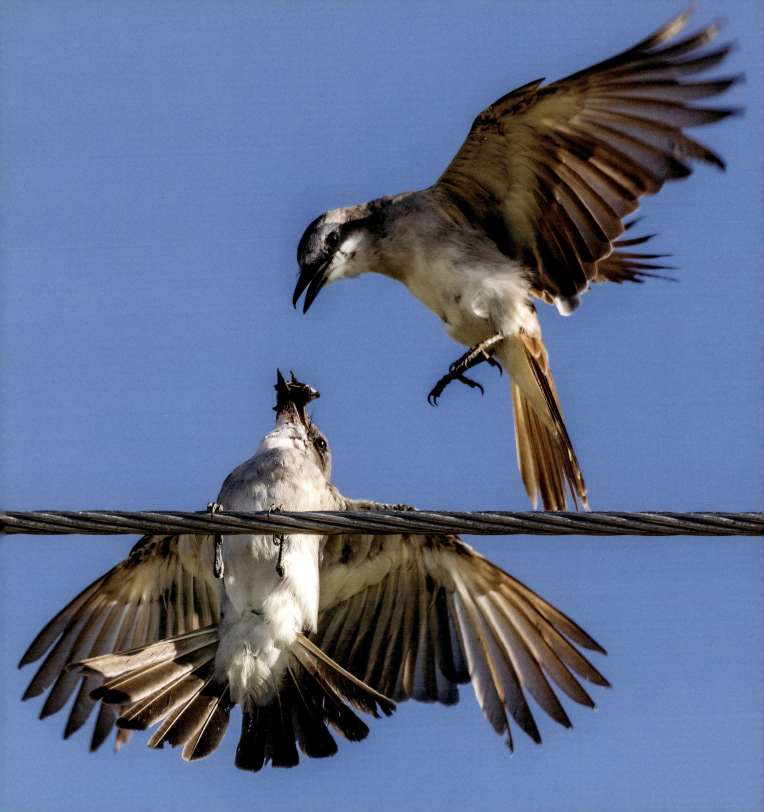

Salty Singer

This cute little lady was working her way along the forested edges of our dirt driveway one summer evening, flitting from branch to branch at warp speed, focused on finding small insects. When she paused briefly to look at me standing nearby, I quietly made a warbler call (one I use very sparingly so as not to distract them from their activities). Instantly, she looked out at me, and to my surprise, flew over and landed on my head!

This was not what I had expected. A goofy smile came to my face as she stepped around on my visor. After a brief period, she finished her inspection and returned to her insect-hunting business, leaving me to ponder nature's little gifts.

Only a few species of warblers live and nest in the Florida Keys. These prairie warblers are a subspecies of their migratory cousins. During the late winter months, if you get out to the edges of the islands in the mangrove and salt marsh areas, you'll hear the males singing to attract females. It's a pleasing melody with a buzzing *zzzz* sound slowly rising to seven or eight notes. It's one of our first signs of spring.

How To Help

Numerous studies have shown that free roaming cats, both feral and domestic, have huge impacts on bird populations. Consider a catio: from simple to extravagant, these outdoor cat patios help keep them safe from predators and disease, plus protect birds and other wildlife from cats — a win-win!

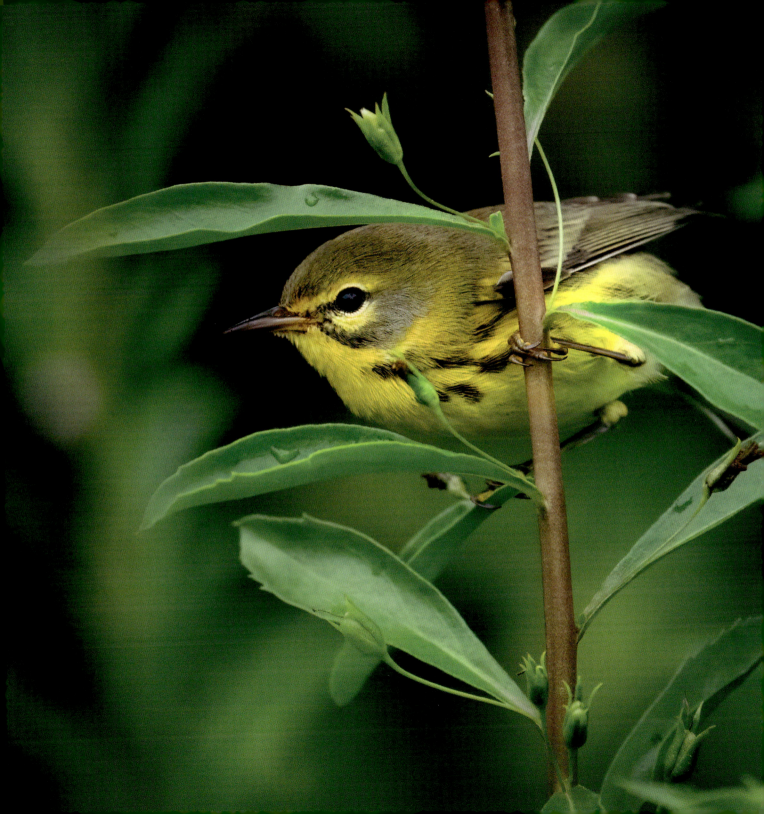

Hurricane Season *Yikes!*

Hurricanes are part of life in the tropics. They are natural phenomena, but recent scientific evidence suggests they are getting stronger, wetter, and capable of intensifying more quickly, due to the impacts of climate change. Technically, hurricane season runs from June 1 to Nov 30th — half the year! For those of us who live here, there is a great sigh of relief once things settle down in late fall, although we all know it's not a matter of *if* the next one will hit; it's *when*.

Catastrophic hurricanes have been documented through the centuries. In 2017, the Florida Keys were impacted by Hurricane Irma, a catastrophic Category 4 storm. I remember watching weather updates from the National Hurricane Center for the whole week following Labor Day weekend, as Hurricane Irma beelined toward the Florida Keys at 185 mph, never wavering in her course.

It is difficult to describe the feeling of absolute helplessness preparing for a large hurricane. It was a terrifying experience to secure our workplace and home, pack our pets and most precious belongings, and evacuate, not knowing what the future would hold.

This photo was taken on Long Beach, after Hurricane Irma. The following photos help tell the story of nature's losses and recoveries in the months and years following a catastrophic storm.

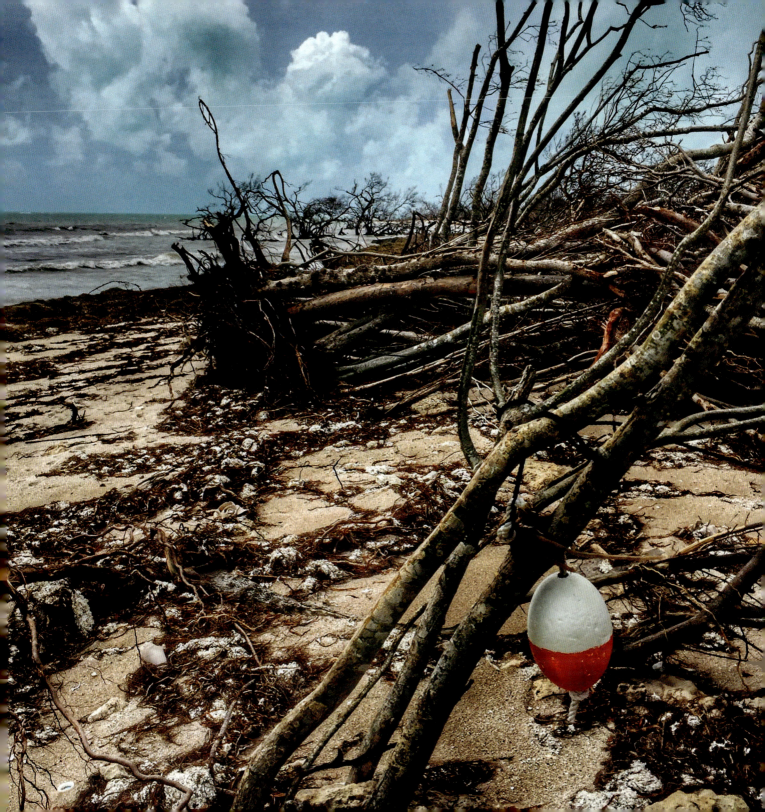

An Icon Lost

Having access to an iconic tree in a beautiful setting is a landscape photographer's dream. This decades-old red mangrove was rooted in limestone in the shallow waters on the ocean side of Big Pine Key, in the National Key Deer Refuge. I spent many an early morning there, trying to capture it in all of its glory, accompanied by a perfect sunrise.

I remember this February morning was especially cold, nearing 45 degrees Fahrenheit (which is nearly as frigid as it gets in the Keys). I remember putting on long underwear to stay warm! As I stood there shivering, I couldn't help but be awed by the night skies transitioning into daylight. I captured this image as the stars faded and the blue light gave way to the golden hour.

You tend to think of many things in life, especially trees, as permanent fixtures of the landscape. Always there, providing balance, continuity, and comfort... until they're not. The brutal wind and waves created by Hurricane Irma hit this area directly, and were too much for this iconic tree to withstand. Although the roots and branches stood firm, the tree never regrew its leaves. It died, and five years later all evidence of its life was gone.

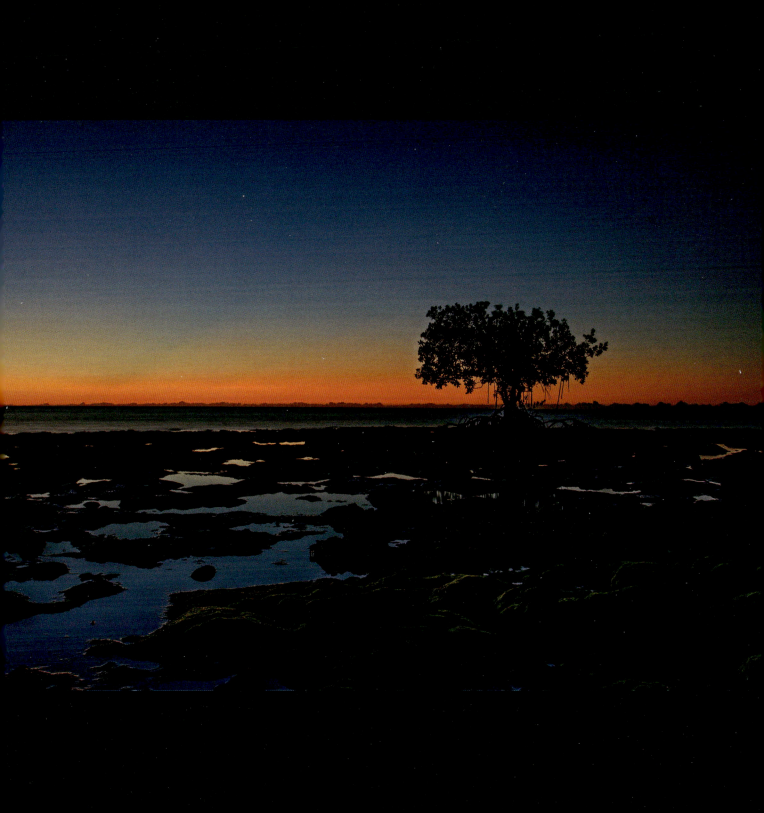

Nature's Recovery

At landfall, the eye of Hurricane Irma centered around Cudjoe Key, with islands nearby being pounded by its wrath. Storm surges were ten to twelve feet on southern and eastern exposures, with sustained winds of 130 mph, plus even stronger gusts. In the aftermath, Irma left behind an apocalyptic scene. Homes were destroyed, businesses flooded, boats tossed, and roads washed away. The natural world was equally impacted. Trees were uprooted, plants were dead and dying, and freshwater habitats were inundated with saltwater.

Much hope was lost. And yet, almost immediately, Mother Nature began the slow process of healing. People shared photos of Key deer wandering in the hardest hit areas. A brown pelican milling about. A box turtle crossing a road. A marsh rabbit in a wetland. A crocodile in a canal. In just a few weeks, wind-whipped landscapes showed signs of new green growth. Wildflowers poked their heads above the soil, and there was much rejoicing at these small signs of nature's recovery.

One of the earliest recolonizers of the barren landscapes was the blue mistflower, a Florida Keys native. As soon as they bloomed, monarchs and other butterflies appeared, searching for nectar. It was a sign of hope at a very difficult time, and a token of nature's resilience in the face of a calamitous natural disaster.

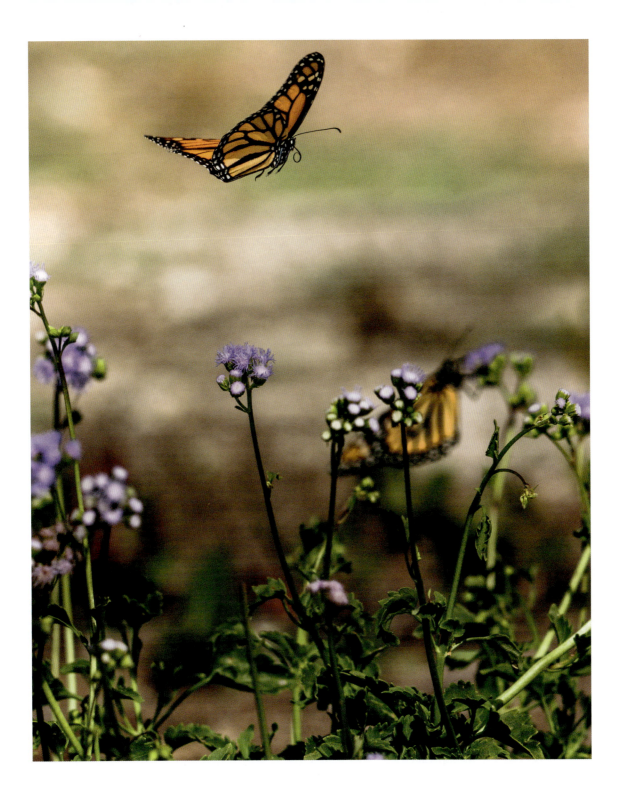

Gumbo in Limbo

Coastal trees, like this gumbo limbo, have faced many storms. But the wrath of a Category 4 hurricane and the accompanying winds, waves, and storm surge were too much to endure. After the storm, I'd periodically check on this majestic tree perched on a sandy bluff facing the ocean. Each year, it would sprout new leaves, but they'd shrivel and drop off as the season progressed. I knew its time was limited.

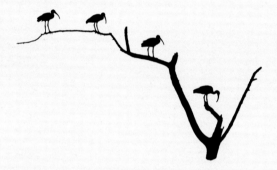

I have a thing for silhouettes. As my photography skills have advanced, I've really come to appreciate nature photography's artsy side, too. You can find some amazing light and colors at sunrise and sunset here in the Florida Keys. I took this photo at sunrise in the Long Beach area of the National Key Deer Refuge.

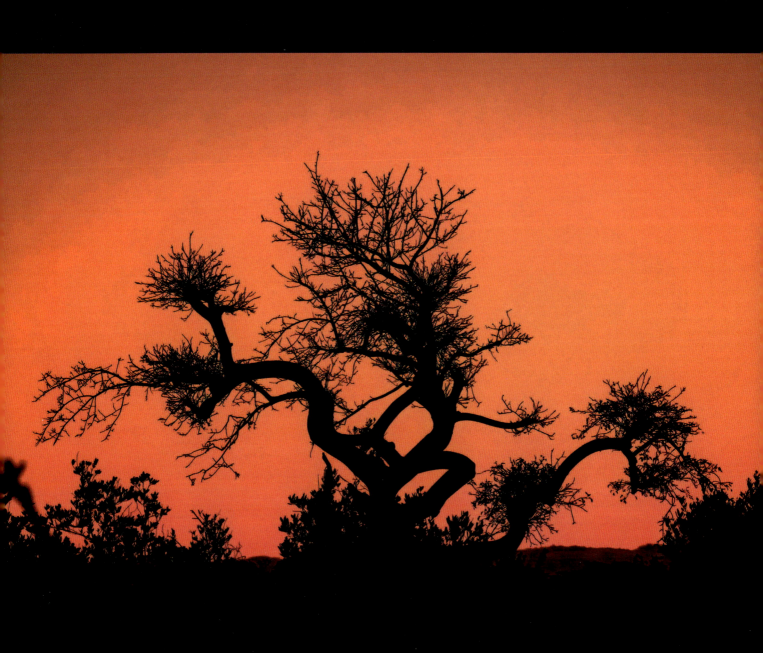

Room for Improvement

The undersea marine world did not escape the wrath of the storm. Tons of marine debris, including commercial fishing traps and traplines, were wrapped around corals and ensnared mangrove shorelines. Even with the heroic efforts of volunteers dedicating thousands of hours to remedy the problem, many islands remain littered with hurricane-scattered man-made trash years later. We need to do better!

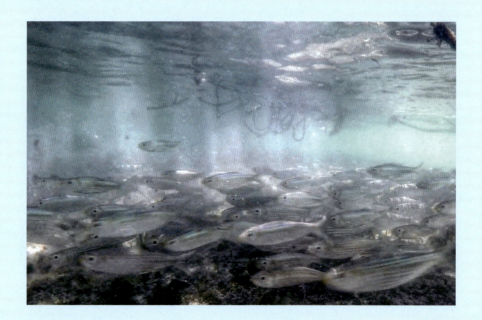

Above: a school of baitfish swims below a tangle of traplines. Right: I was out walking my dogs one evening, a few years after Irma when I encountered a large barge parked in our canal. The county had received a grant to remove hurricane debris, and for two weeks the barge came and went, filled to the brim by volunteers and commercial fishermen. This photo gives you an idea of the scope of the problem, but by no means represents the enormity of the trash that has been removed in the ensuing years. To this day, cleanups continue.

Spearfishing Specialists

The majestic great white heron is unique to South Florida and the Florida Keys. They are officially considered a white color morph of the more common great blue heron. But some enthusiasts and scientists have speculated that because of their subtle differences, they might be a subspecies or even a separate species, which leads to engaging conversations in the birding community.

Great white herons forage for fish and invertebrates along large, continuous seagrass beds when the tidal cycle is just right. They spear prey with their beaks, then deftly flip it up and backward to swallow. Nesting occurs year-round, with a peak between November and February, primarily on backcountry mangrove islands. After Hurricane Irma, surveys showed that they still had relatively high occupied nest numbers, suggesting these majestic birds are quite resilient.

I'm thankful that more than a century ago, citizens, scientists, and policymakers acknowledged a horrible truth — that harvesting the feathers of beautiful wading birds like herons, egrets, flamingos, and spoonbills for the fashion industry was unsustainable. Two of the Florida Keys' four national wildlife refuges, Key West (1908) and Great White Heron (1938), were established to protect these magnificent birds from extinction.

One question that arises on birding adventures is, "How do I tell the difference between a great white heron and a great egret?" Both are large, white wading birds, but generally, great whites tend to have yellow legs versus an egret's black legs.

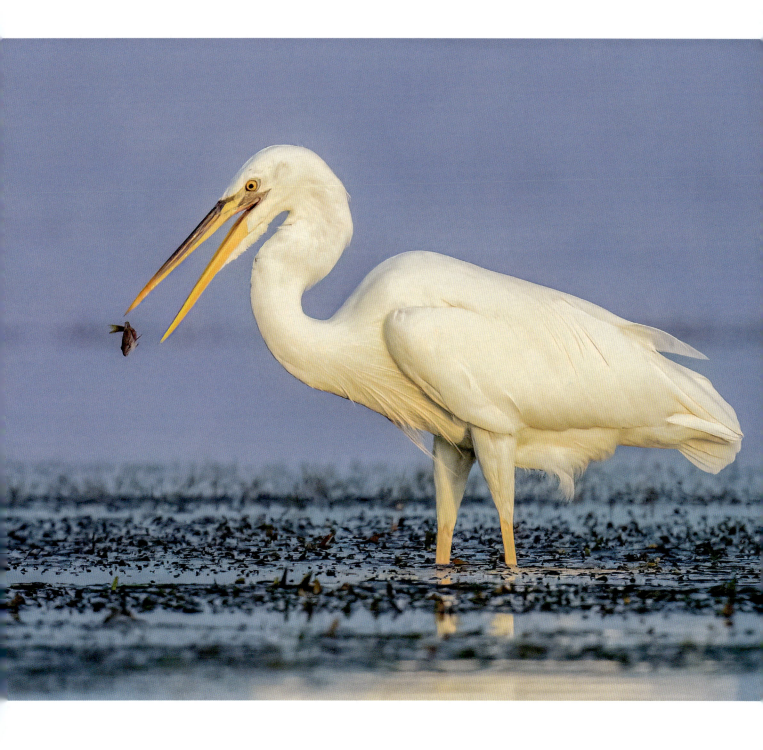

Doorway on the Wall of Time

I imagined creating a photograph that would tell the story of an old, abandoned farmhouse in the woods. I'd been there several times doing wildlife surveys, and was always intrigued.

I set off early on a hot, humid day with camera gear and props including flowers, a book from our little public library, "ghost clothes," and snake chaps (yes, seriously, there are rattlesnakes in remote areas). The hike was only a mile, but the heat was unbearable. I couldn't remember exactly where the house was, so I stumbled around for a while until a curiously placed coconut shell caught my attention. It marked a path winding farther into the woods, which ended at a house.

But the cute little farmhouse I recalled was nowhere to be seen. I wondered if I was in the right place. This house was ground level, not elevated like the one in my memories. I felt lost and confused. Finally, it dawned on me that Hurricane Irma's powerful storm surge must have lifted the house off of its elevated foundation and placed it in a pile on the ground — the concrete front porch stairs were still there, but rising to nowhere. A stark reminder of the hurricane's fury.

To create the ghosting effect in the photo, I used a long exposure. I thought white clothes would work well, so I changed from my hiking clothes into my ghost outfit in the shade of the trees. The goal was to be present in the photo for about half the exposure, then quickly exit the frame, creating an ethereal-looking subject. So, I sat still for about 10 seconds, then I got up and raced out of the picture, cringing as I tried not to step on rusty nails with bare feet.

I like how the photo turned out. I feel it captures a juxtaposition in time; a then-and-now kind of feeling of a once-vibrant farmhouse, with one to which time has not been kind, but that nature is re-embracing. And my adventure to create the photo, well, that became a memorable story in itself!

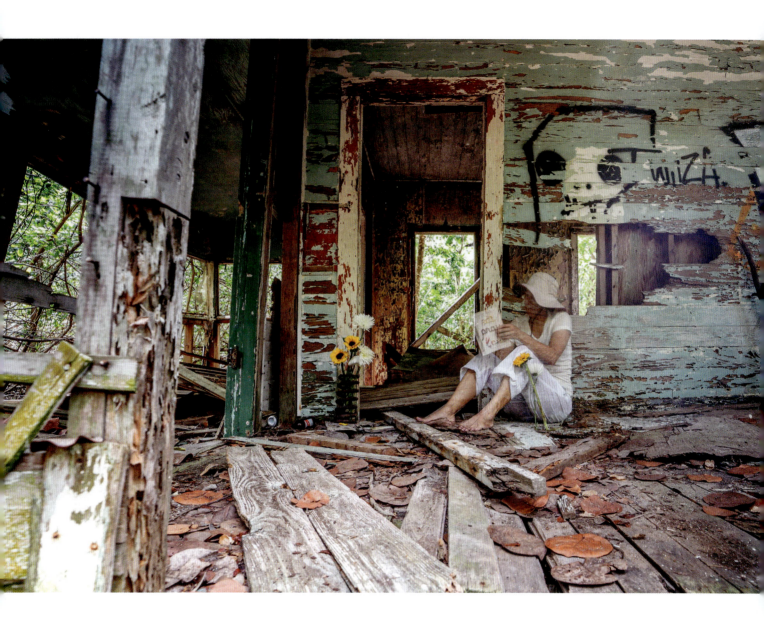

Autumn *The Breeze Returns*

Ever so slowly, there is a detectable change in the weather. The days shorten. The sun doesn't feel as intensely hot. Migratory birds begin to head south. They'll have layovers in the Florida Keys or pass well overhead.

Our winter residents, like belted kingfishers, great crested flycatchers, and white pelicans, return. Summer residents, including white-crowned pigeons, gray kingbirds, yellow-billed cuckoos, and others, head farther south.

Autumn marks the start of Key deer mating season, aka the rut. Bucks will rub the velvet off of their antlers and begin challenging other males to battles for breeding rights. With younger bucks, it's usually not much more than a short scuffle or practice for future years, but the big males, who are five to seven years old, fight with an intensity that can leave them wounded and exhausted.

This mature male Key deer was just beginning to lose his antler velvet. Within a week or two, he was sporting a sharp set of antlers and beginning to joust with other males. The photo was taken just a few weeks after Hurricane Irma hit. While some of the Key deer lost their lives in the storm and its aftermath, most of them survived, even in the hardest hit areas. Although Madagascar periwinkle flowers are exotic to the Keys, they provided a welcome bit of color to help us through a stressful time.

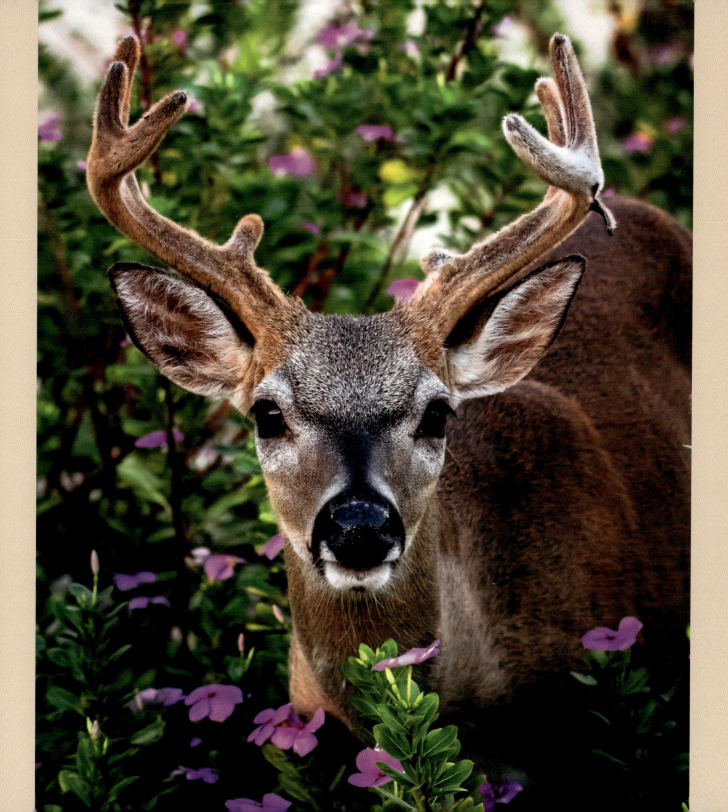

Returning Home

Did I mention that I love ducks? In autumn, we welcome home the blue-winged teal, returning from their nesting grounds in the northern US and Canada. They'll live here for the next eight months, feeding primarily on aquatic grasses.

This female blue-winged teal was stretching her wings one morning on a brackish-water pond. I loved how the rising sun backlit her wings, with water droplets spraying in every direction. You can easily see her namesake blue feathers that are only visible in flight or when her wings are outstretched.

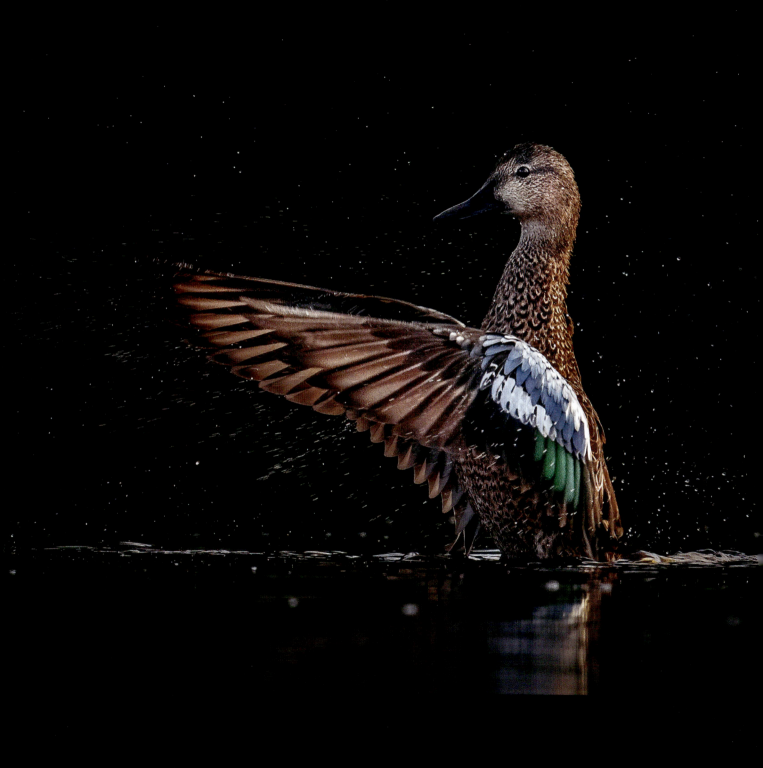

Take Out

My fondest memory of these striking birds is the first time I saw one. I was sitting on my back porch with my father, who was an avid birder. Neither of us had ever seen one, and we were thrilled to watch it bobbing and weaving over the tree line, searching for prey. Swallow-tailed kites feed on the wing, grabbing insects and lizards from trees with their talons mid-flight and gobbling them up while airborne. It was beautiful to witness.

A few days later, my father suffered a massive stroke, from which he never recovered. He passed away shortly after. I was so happy to have shared that magical moment with him.

It was several months later the next time I witnessed a swallow-tailed kite from my back porch. Two flew together. I was instantly struck by a sensation that my father was out there, with the bird spirits, flying free. Note: look closely at the photo, this kite has insect snacks in both talons.

Swallow-tailed kites are magnificent hawks who undergo extraordinary seasonal migrations. They nest in mainland Florida in the spring and summer, then are some of the first fall migrants to depart for their wintering locales, leaving in late July for South America. Prior to taking off, they gather in pre-migration groups that can number into the thousands.

One afternoon I witnessed a flock exceeding 300 individuals streaming southbound over Curry Hammock State Park in Marathon. Another time on No Name Key, I saw about fifty rising silently at dawn to continue, after resting overnight. It's hard to describe how amazing it is just to see one or two. To see them in such numbers truly dazzles the senses.

Peak Acceleration

You've probably heard that peregrine falcons are the world's fastest bird. They can reach speeds up to 200 mph as they dive bomb toward unsuspecting birds. Sometimes they hit their prey with their feet, stunning them and allowing for easy capture. Other times they'll grab an unsuspecting bird mid-air or along a shoreline.

Each year thousands of peregrine falcons pass through the Florida Keys, migrating south to wintering grounds in the Caribbean and parts of Mexico. Some choose to stay in coastal areas of the southeast US, including Florida. According to Florida Keys Hawkwatch, more migrate south here than anywhere else, making the Keys the "peregrine falcon migration capital of the world."

I could see this young peregrine falcon approaching from a distance, soaring south to north along the inside of the beach line. I got my camera ready and increased my shutter speed to ensure focus. She gave a downward glance when she got directly overhead. I think I heard her whispering, "Mere mortal, get out of my way!"

Where to See Them

Fall migration season typically peaks in September and October. Keep an eye on the sky. Beaches are good places to see them gliding past, looking for shorebirds. Or join Florida Keys Hawkwatch at Curry Hammock State Park in Marathon for a front-seat view of migrating hawks and falcons.

King of the Shoal

*A*s a kid who loved the ocean, I devoured the book "Jaws" and watched the movie with enthusiasm. I wasn't scared as much as I was curious about these often-maligned creatures. I did my master's research on blacktip sharks in Tampa Bay, but none of that involved seeing them underwater; I never witnessed that until I visited the Florida Keys. And I do have the world's craziest shark story, but you'll have to ask me about that later!

Caribbean reef shark passed me by one autumn afternoon, surrounded by an entourage of bar jacks. The smaller fish hang out with the shark, hoping to score leftovers. They also are afforded some protection by their bigger friend. Although I have caught a lot of sharks in my life, seeing them underwater, gliding gently along, gave me a different perspective. I now prefer just to watch them in their underwater realm.

Sharks are apex predators who help maintain balance in ocean wildlife populations. Florida Keys' sharks include Caribbean reefs, bonnetheads and other hammerheads, nurses, bulls, blacktipss, lemons, tigers, and occasionally notorious great whites. Even the world's largest shark, the plankton-eating whale shark, is seen here.

Where to See Them

The easiest place to safely view sharks is offshore at the coral reef tract. At Looe Key Reef, it isn't unusual to spot several on a snorkel or dive excursion. One of the most common sightings is the Caribbean reef shark. During the daytime, they are in chill mode, calmly swimming through the undulating topography. They'll do most of their hunting at night.

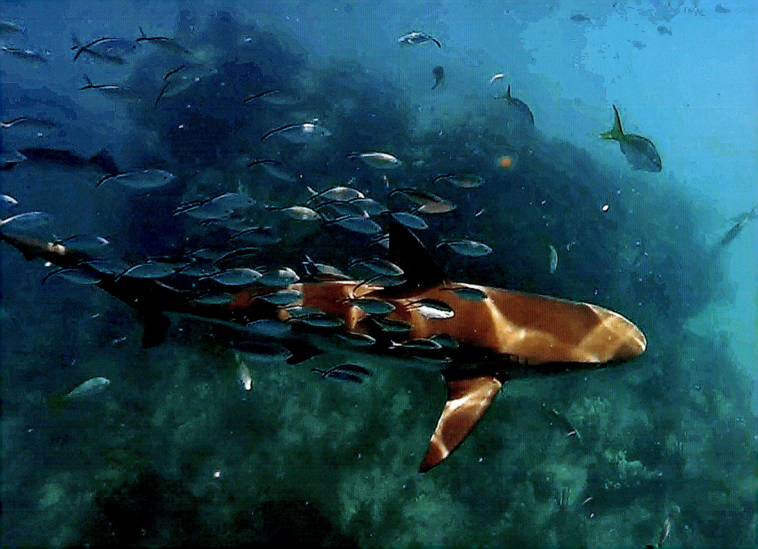

Scat Master

One of my first jobs at the Florida Keys National Wildlife Refuges was surveying about twenty-five islands for evidence of the endangered Lower Keys marsh rabbit. These rabbits are secretive and difficult to observe. They prefer thick ground cover near wetlands, where they can create networks of tunnels to feed, hide, and move about undetected by predators.

One way we could tell if they were present was by locating their scat. Scat is just a science term for animal poo. If we found scat, we knew we'd found their habitat, which we affectionately called "rabbit-at."

Scat surveys are integral parts of wildlife management, so when we created the Refuge's Junior Ranger program we added that into the activities. It quickly became a big hit. We had about fifteen lifelike varieties of animal scat, which participants would match to a particular animal on a photo board. We called that the "scat mat." Depending on how well they did, they received a ranking, with the lowest being "Dung Dealer," then "Poo Professional." The highest honor was "Scat Master." I cannot take credit for these witty award levels. They came from a brainstorming session with kids.

One morning when I arrived at the Nature Center, the new volunteers said, "You've got a big rat in here or something." I asked what they meant. "We found a pile of giant poo on the table." I asked what they did with it, and they said they flushed it down the toilet! We all laughed when I explained it was a plastic replica. It ended up being cheaper to purchase a whole new set than to just replace the missing item — although my expense report raised some eyebrows, with my manager questioning whether I had indeed purchased a "bucket of scat!"

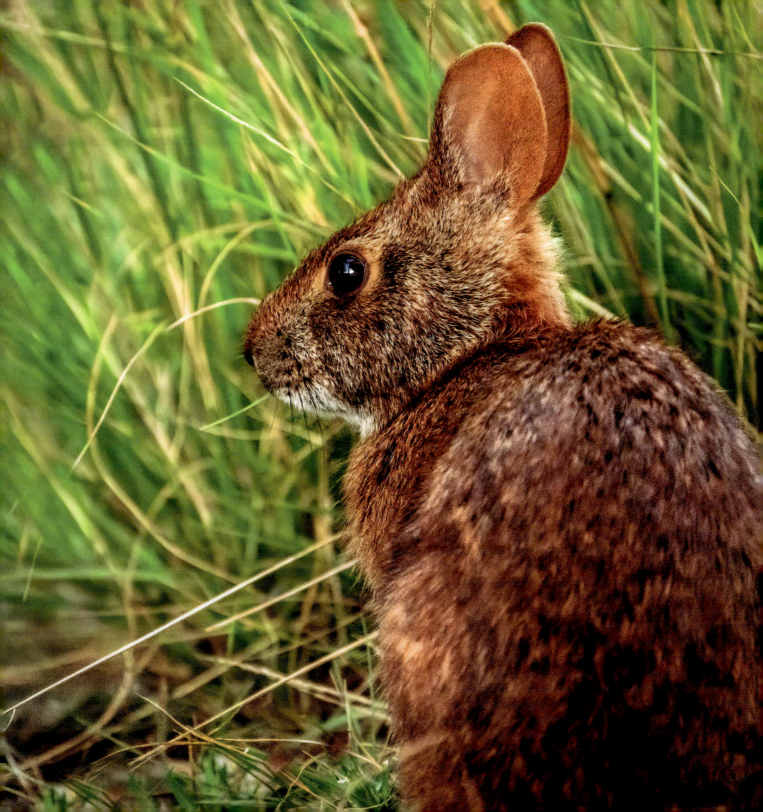

Wild Imperfection

We've been led to believe that one's yard should be an immaculate monoculture of lush green grass, free from weeds, insects, or any form of wild nature. We've been bamboozled! These often-chemical-laden lawns offer little to support native wildlife.

Do not fear, because you are at the helm. I encourage you to go a little wild! You can turn your yard into a bountiful nature preserve with just a few minor changes.

- Plant some trees.
- Add a pollinator garden or two.
- Don't let "weeds" bother you; many are just native wildflowers you haven't yet met!
- Give nature your edges and corners. The adage, "If you build it, they will come," holds true when creating habitat for wildlife.

Goatweed (right) is a leggy herbaceous plant that often volunteers in disturbed habitats. This zebra longwing butterfly — Florida's state butterfly — returned several times to gather nectar from this often-overlooked plant.

Northern cardinals (far right) are year-round residents in the Florida Keys. This one was on the ground in my yard, nibbling on Creeping Charlie, a weedy herbaceous perennial.

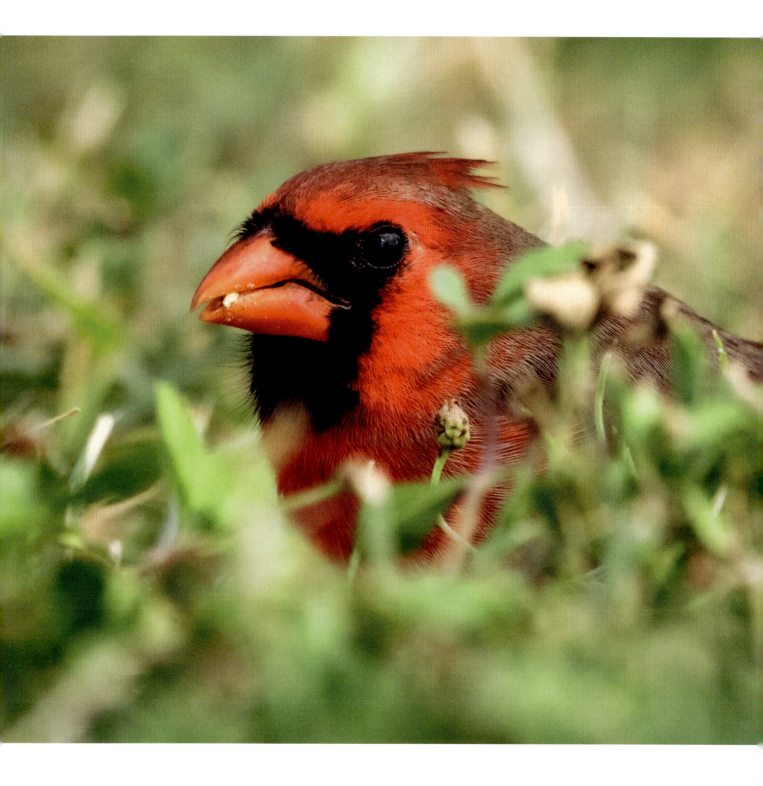

Rare Visitors & Crazy Bird People

There are enthusiasts for all sorts of nature, but the most well-known of the lot are birders. Some start at a young age; others blossom with maturity. There are contests, like The Big Year, where birders travel the US and Canada looking and listening for different birds, often finding more than 700 species. Other birders travel the world, adding to personal "Life Lists."

Regardless of your interests or level of birding addiction, you'll find plenty to make you happy in the Florida Keys. Almost 300 bird species are listed in the US Fish and Wildlife Service's Florida Keys bird list. And there are dozens of places to explore.

A good starting point would be the eBird app run by the avian experts at Cornell University. You can search for a particular bird species or look for birds recorded at nearby "hotspots." The app also includes alerts for rare or unusual bird sightings.

*O*ne autumn, this Cuban pewee (right) became a local celebrity at the Blue Hole observation area on Big Pine Key, in part due to the widespread use of the eBird app. Native to Cuba and the Northern Bahamas, this little flycatcher attracted birders from throughout the country who traveled great distances by car and plane to catch a glimpse of him. Being at Blue Hole with a gathering of ten or twenty like-minded admirers wasn't unusual, and it was a treat to hear stories of the crazy journeys this one bird, who'd undergone a momentous journey himself, inspired. Other birds, like the red-shouldered hawk (above), are homebodies, but also fascinating. They live year round in the Florida Keys, nesting in tall trees in pine rockland habitat.

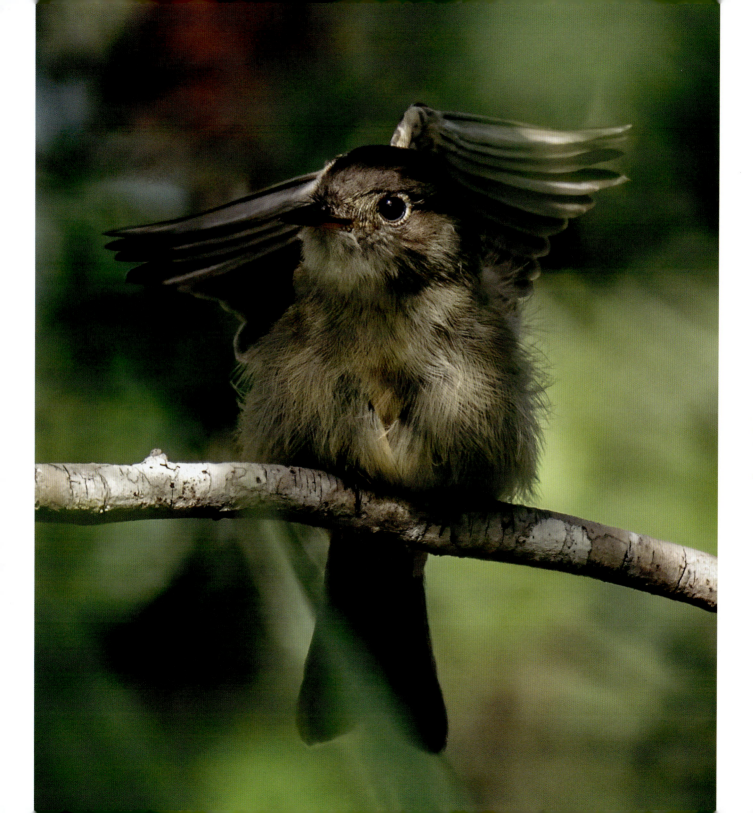

Pink Persuasion

As a general philosophy, I don't chase birds. I'm not referring to physically pestering or being unethical or anything; it's a friendly term for birders who ramble off on a twelve-hour drive or a three-hour plane flight to see some "little brown job" who popped in randomly or strayed off course on a migration. I have nothing against those who do. I've just always taken a more leisurely approach to nature viewing.

I stand unwavering in my ideology… Wait. What's that? I just got a text from a friend who says her friend thinks she saw a wild American flamingo. Full stop. Cancel the afternoon meetings. Re-configure that timesheet to reflect comp time for the rest of the day, and get out of my way. We are going flamingo hunting!

Admittedly, and sheepishly, I'll concede that I am a sucker for those gangly, alluring birds who pop into the Florida Keys for a brief visit. We are at the upper end of their range, but they rarely end up here. Part of the excitement is the unpredictability of it all, with sightings usually a result of someone stumbling upon them.

Witnessing an American flamingo in the wild is a soul-enriching experience. Cherish the moment if you are given the opportunity.

This American flamingo appeared at The Horseshoe on Scout Key in January, 2022. It might look like I was close, but I wasn't. I used a large telephoto lens. In hindsight, I wish volunteers could have been stationed nearby to reach out to the public, since this bird suffered quite a bit of disturbance from people approaching too close. I'm sure most just didn't recognize her need for space. She left after just a few days, leaving me wondering if we, as a community, had failed her trust. I'm hopeful that in the future, we'll do better. I always encourage everyone to practice ethical wildlife viewing; let's make sure we prioritize the welfare of the creatures above all.

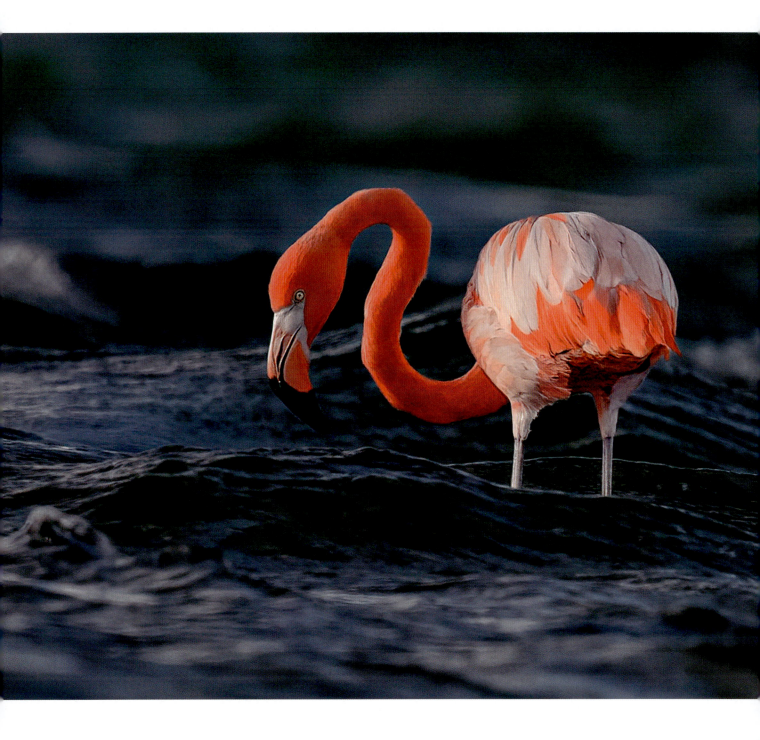

Nature's Clean Up Crew

Turkey vultures are year-round residents of the Florida Keys, although many more also migrate here for the winter months. They play an important role in the ecosystem as scavengers, locating dead animal carcasses using their incredible sense of smell. Groups of turkey vultures can quickly "recycle" everything down to skin and bones within a day or two, even with large animals like Key deer.

Turkey vultures roost with friends during the evening hours. As morning comes and air temperatures on land rise, updrafts create optimal conditions to keep them aloft. They'll soar for hours searching for a meal. The characteristic teeter-totter rocking motion of their flight helps distinguish them from other large, soaring birds.

A few years back, the USDA looked at potential conflicts between aircraft and turkey vultures at Naval Air Station Key West, since potential collisions with these large birds is a serious safety concern. They tagged some with large, numbered wing tags, and asked the public to report sightings. As the refuge park ranger, I remember fielding a call one day asking what was happening in northern Big Pine Key; many of the tagged birds were being reported there, 30 miles from the air station. When they gave me a more specific location, I realized what was up — it was a place where the refuge put Key deer killed on roadways. We always referred to it as "the boneyard," and the vultures used it as an outdoor restaurant.

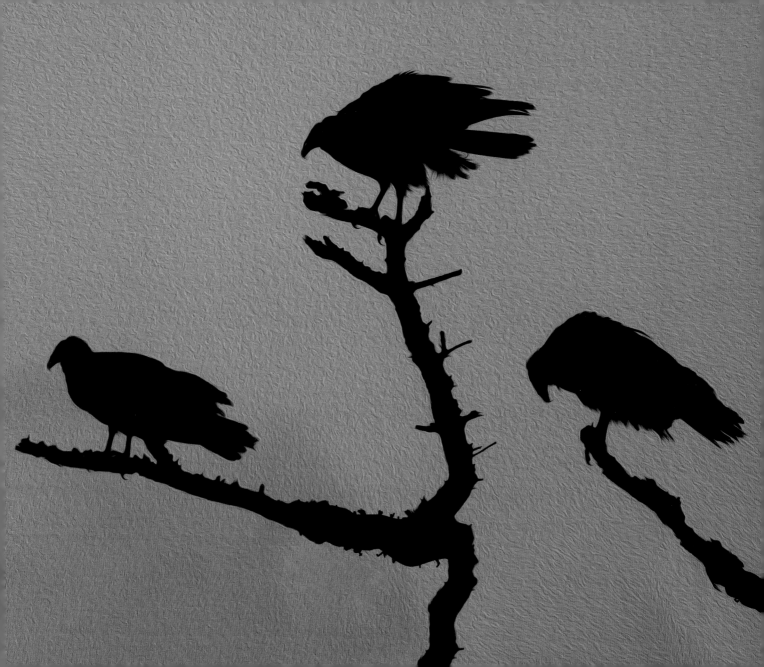

Gentle Giants

The Florida manatee was designated the state's official marine mammal in 1975. While this iconic species is found in the Florida Keys year-round, manatee populations increase in winter when some migrate south to avoid cooler waters.

Manatees are herbivores (plant eaters) who feed on seagrass and other aquatic vegetation in Florida's rivers, bays, and coastal areas. Adults typically grow nine or ten feet long, often weighing more than 1,000 pounds. Manatees need to eat about four to nine percent of their body weight daily — that's thirty to 100 pounds of aquatic plants! They may live up to sixty years, but that isn't typical. Threats to their longevity include habitat loss, red tides, and boating mortalities and injuries.

Whether walking along a dock or drifting by on a boat or kayak, I'm always starstruck when I see a manatee. They bring my activities to a complete standstill. I fondly remember the few times they've sidled up while I was out snorkeling. Their large size made my heart race before I realized who they were.

I'm embarrassed to divulge that I've lived in Florida for a third of my life and don't yet have a decent photo of a manatee. A friend was generous to allow me to use hers. Thank you, Jessica Rainard.

How to Help

Use caution while boating in shallow seagrass habitats and manatee zones. Wear polarized sunglasses to increase your ability to see creatures under the water. Don't provide them with food or fresh water; it is illegal and changes their behavior, making them more prone to injuries.

Kleptoparasite

Magnificent frigatebirds are beautiful soaring seabirds with slender, angular wings and a forked tail. They are also kleptoparasites, meaning their primary feeding strategy is to steal fish from one another and from other seabirds. I once watched one chase a royal tern for a minute or two. They flew circles through the air, then the frigate grabbed the unfortunate tern with its beak, causing it to drop its fish, which was immediately swooped up by the frigate.

Another time, my husband and I were out at the reef line, drifting along, fishing, and enjoying the ocean experience, when our focus turned to two magnificent frigatebirds: one sailing high above and the other down low, both watching us intently.

At some point, a small piece of bait ended up in the water, and the lower frigate moved to take a closer look. Almost immediately, we were struck by a loud sound of feathers tearing through the air. The second frigate had descended quickly and come to an abrupt halt. Both birds skirmished, with the high-flier ultimately being the victor. The entire encounter took only a few seconds, reminding us that in nature, speed and agility can mean life or death. We humans can only admire these athletic talents from afar.

Where to See Them & How to Help

Look for magnificent frigatebirds soaring above Florida Keys waters, offshore and into the backcountry. They are colonial roosters and will perch by the dozens, sometimes hundreds, on small mangrove islands. Give their rookeries space while boating or fishing. Human disturbance can cause entire colonies to give flight. If this happens repeatedly, they might even abandon their necessary resting areas. If you accidentally catch a frigate, don't cut the line; reel it in and carefully remove the hook.

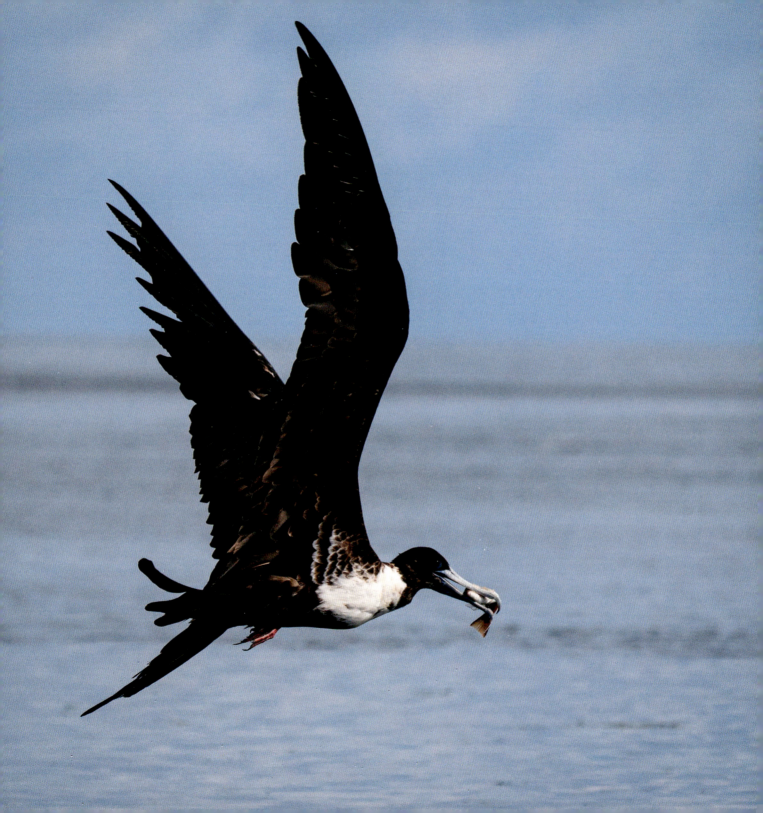

When Nature Laughs

It was winter and a cold front was approaching. The wind picked up and white caps topped the waves. As I pulled my kayak into the protected waters of our canal, our resident alligator greeted me. We exchanged pleasantries, and I headed onwards.

Climbing out, I left my paddle on the floating dock and pulled the kayak onto land. A neighbor beckoned, and I went to chat, ultimately forgetting about my lightweight paddle — a precious and expensive gift from my husband — which was sitting precariously on the edge of the water, at the mercy of an ever-increasing wind.

It wasn't until a day later that the thought of my paddle popped into my head. I convinced myself all would be fine. It wasn't, it was gone. Although a cold winter night was settling in, I decided to don my dive gear to give a look-see. My husband said I was crazy, but I was undeterred. With my wetsuit on, I departed into the dark water.

I'm strong-willed, but when I finally reached the bottom, I was horrified by the creepiness. My flashlight fell on spiderwebs of decomposing seagrass, and when I pushed my hand into the bottom muck, it disappeared to my elbow. The eeriness got the best of me and I surfaced, having only spent a minute or two searching. Dejected, I vowed to return during the daytime to conduct a proper search-and-recovery effort.

The next day at work, I was sharing the story of my ill-fated diving adventure. "Don't kayak paddles float?" the group asked. I said, "Maybe initially, but I don't think they could withstand twenty-four hours of immersion."

It got me thinking, and I called my neighbor across the canal who had the same paddle. I inquired whether I could borrow hers for an experiment. After work, I went straight there, grabbed her paddle, and jumped onto her boat. Carefully lowering it I observed that it did float! Interesting! As I stood up, my eyes were drawn to an object directly across the canal; there, cradled gently in two seagrape limbs, floated my precious paddle! I'm sure I heard Mother Nature laugh, although it could have just been the wind.

Photo right: Kayakers enjoying Rachel Carson Key.

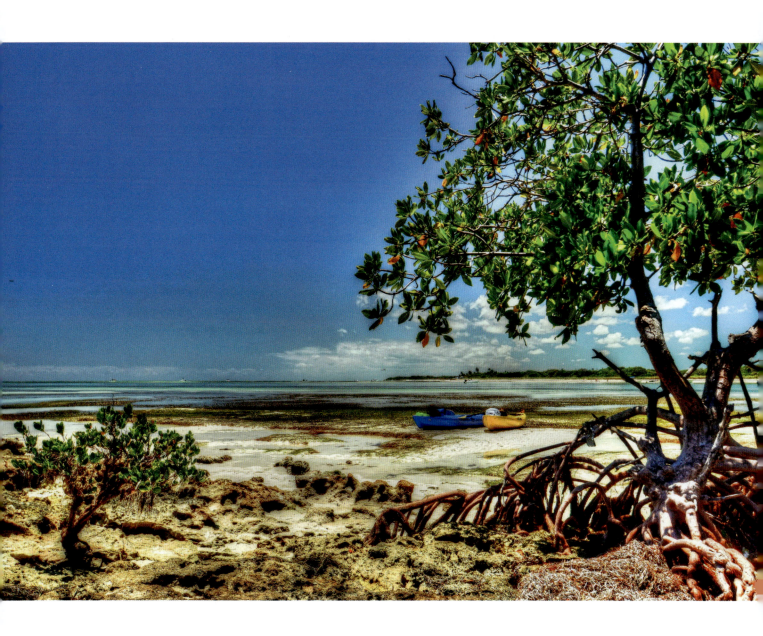

People Power

One would hope that natural resource agencies, whose missions are to conserve nature, would have adequate funding to support their goals. Unfortunately, this isn't often the case. Shortfalls in budgets and staffing present constant challenges, and refuges and other preserves rely heavily on volunteers to fill these gaps.

As a park ranger, the hundreds of dedicated volunteers I worked with brought daily smiles to my face. I could not have done what I did without their help. Some donated a few hours, others a few days, and some amassed thousands of volunteer hours!

A shining example: the endangered Key Largo woodrat (right) persists today in large part because of the dedication of volunteers. Two brothers, Ralph and Clay DeGayner spent more than a decade building thousands of supplemental nest structures and removing non-native predators in Crocodile Lake National Wildlife Refuge. They volunteered thousands of hours, braving hot, physically demanding, mosquito-infested conditions — while in their 70s and 80s, no less — to give these diminutive creatures a fighting chance for survival. (Photo, right, by Clay DeGayner.)

From education and outreach, to maintenance and construction, biological surveys, photo clubs, Friend's groups, trash cleanups, kids' activities, veterinary care, newsletters, and infinity and beyond, the role volunteers play in natural resource conservation needs to be acknowledged, celebrated, and shouted from the rooftops!

I'm retired now and enjoying volunteering as well. It is a rewarding experience. You meet incredibly enthusiastic people, and make lifelong friends who care deeply about nature. I encourage you to consider volunteering. Find something you really enjoy, something you have a passion for, and go help make a difference!

The End & New Beginnings

Well, I hope you've enjoyed my photographs and stories, and that they encourage you to take yourself, friends, and family outdoors to enjoy nature in the Florida Keys and beyond!

On the next page is a checklist of activities you can do to lend nature a hand. These include direct actions, like volunteering and landscaping with wildlife in mind, as well as how to be a voice for nature through advocacy and support. We all need to work together to ensure that these magnificent places, and the plants and animals who live in them, are here for future generations to appreciate.

What are my future plans? Thanks for asking! I hope to keep learning and exploring. I'm going to continue honing my photography skills and working on taking wildlife photos from a bit of an artsy perspective. Perhaps in the future, I'll dabble in seascapes or underwater photography. Or maybe I'll just go off to swim with the fishes. Or... well, you get the idea.

I'm always in awe of how quickly the landscape can change in a short period of time. One morning as I sat on the beach, the sun ascended from the dark horizon. I noticed a seam in the clouds that looked like a portal to another universe. As the sun climbed above the opening, golden rays of light shone downwards, giving the scene a heavenly feeling.

This was one of my mother's favorite photos. She loved the sun silhouetted in the morning glow. Viewing this always reminds me of her love, and her support for my photography. I call this one "Icarus."

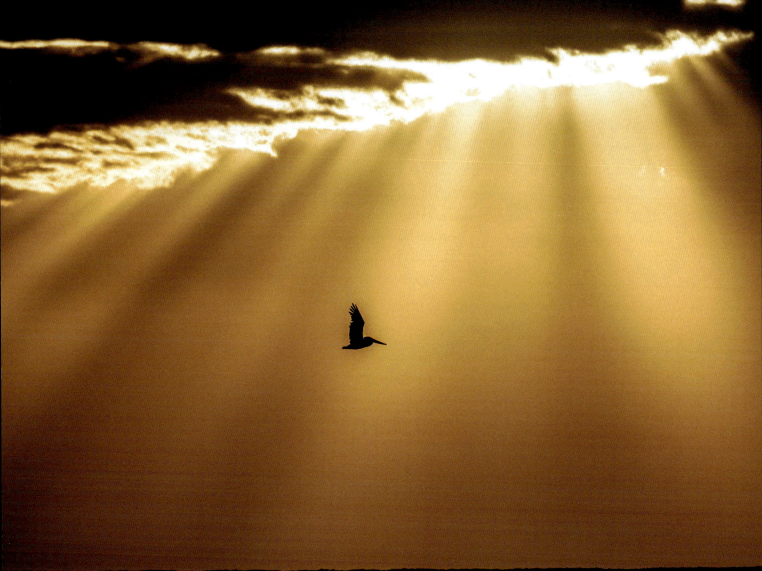

How To Help

- Take your kids, friends, parents, and grandparents outdoors to enjoy nature.
- Respect the regulations at wildlife refuges, parks, and sanctuary areas.
- Practice ethical photography and wildlife viewing techniques.
- Use binoculars and telephoto lenses to get closer, but still keep your distance.
- Don't chase wildlife. Let them come to you.
- Limit the use of bird calls, especially during nesting and migration seasons.
- Don't feed alligators and crocodiles food scraps; they'll learn bad behaviors.
- Don't discard used fishing lines in the water; use an appropriate receptacle.
- Leave no trace of your visit; pack it in, pack it out, and stay on the trails.
- Don't touch or feed Key deer, and always appreciate them from afar.
- Drive carefully in Key deer country.
- Help keep wildlife wild by securing your trash and pet food containers.
- Be a responsible pet owner. Obey leash laws.
- Build a catio for cats to keep them safe from predators and disease, and to protect wildlife.
- Don't release exotic pets. Many state agencies provide for their adoption.
- Limit outdoor lighting, especially in beach areas. Embrace the night sky!
- Reduce your use of single-use plastics, and use a refillable water bottle.
- Purchase products from companies that strive for sustainability.
- Create a wildlife habitat in your yard, and plant a pollinator garden.
- Landscape with native plants, and don't use pesticides and other chemicals.
- Volunteer. Pour your passion into protecting nature.
- Donate money or your time to a wildlife organization or refuge.
- Advocate on nature's behalf by voting for people who value nature.
- Share your knowledge of and passion for conservation with others.

Photo right: Shorebirds resting in the evening glow, No Name Key.

Public Lands in the Florida Keys

National Parks
- Everglades National Park, Homestead and Miami
- Biscayne National Park, Homestead
- Dry Tortugas National Park, 70 miles west of Key West (boat or air access only)

National Wildlife Refuges
- Crocodile Lake NWR, Key Largo (open for volunteer events and during guided walks)
- National Key Deer Refuge, info for all Keys NWRs at Nature Center on Big Pine Key
- Great White Heron NWR, islands and waters north of the Lower Keys (boat access only)
- Key West NWR, islands and waters west of Key West (boat access only)

Florida Keys National Marine Sanctuary
- Waters throughout the Keys, info at Eco-Discovery Center in Key West

State Parks
- Dagny Johnson Key Largo Hammock Botanical State Park, mile marker 106/CR 905
- John Pennekamp Coral Reef State Park, mile marker 102.5
- Windley Key Fossil Reef Geological State Park, mile marker 84
- Lignumvitae Key Botanical State Park, mile marker 77 (boat access only)
- Indian Key Historic State Park, mile marker 77 (boat access only)
- San Pedro Underwater Archaeological Preserve State Park, mile maker 77 (offshore)
- Long Key State Park, mile marker 67
- Curry Hammock State Park, mile marker 56
- Bahia Honda State Park, mile marker 36.8
- Fort Zachary Taylor Historic State Park, Key West
- Florida Keys Overseas Heritage Trail, linear walking and cycling trail, Key Largo to Key West

Photo right: Sombrero reef and lighthouse, Marathon, Florida.

Credits: Stock Images

P 6 iStock, Sea Creatures, by Hachio Nora, ID 1322065558
P 8 iStock, Sea Creatures, by Hachio Nora, ID 1322065558
P 18 Pixabay, Crab, by OpenClipart-Vectors
P 20 – iStock, Diving People Icons, by Irina Gavashenko, ID 1414363591
P 28, Adobe Stock, ducks landing, by Yekaztudio, file 580222194
P 30, iStock, Pelicans Overhead, by George Peters, ID 544680112
P 34 iStock, Alligator, by ELIKA, ID 656448850
P 36, American Crocodile, by Michael Vaughn
P 38, iStock, Artist Palette, by Turac Novruzova, ID 1255827004
P40 Sea Creatures, by Hachio Nora, ID 1322065558

P 46 Adobe Stock, sea turtle, by Arafat, file 647732224
P 50 iStock, Telescope, by Magnillion, ID 1337455990
P 50 iStock, Stars, by Magnillion, ID 1337455990
P 52 Adobe Stock, ants, by Sutana, file 558565398
P 60 iStock, bird flying, by Kristtaps, ID 472296155
P 62 Adobe Stock, by hummingbirds, Loveleen, file 148206772
P 68 iStock, tarpon, by Kvasay, ID 163926929
P 70 Pixabay, two hearts, by Clker-Free-Vector-Images hearts-305259_1920
P 78 Sea Creatures, by Hachio Nora, ID 1322065558
P 80, iStock, Diving People Icons, by Irina Gavashenko, ID 1414363591

Other Hidden Outdoor Gems

Upper Keys
- Rowells Waterfront Park, mile marker 104.5, Key Largo
- Harry Harris Park, mile marker 92.5, Tavernier
- Green Turtle Hammock Nature Preserve, mile marker 81, Islamorada
- Anne's Beach, mile marker 73.4, Islamorada

Middle Keys
- Coco Plum Beach, Marathon
- Sombrero Beach, Marathon
- Crane Point Hammock, mile marker 55.5, Marathon
- Pigeon Key, off Old Seven Mile Bridge, mile marker 47, Marathon

Lower Keys (south of the Seven Mile Bridge)
- Veterans Memorial Park, west end of Seven Mile Bridge, mile marker 39.9
- Ohio Key, mile marker 39 (limited parking, use caution)
- Horseshoe Beach, mile marker 35, bayside
- Pine Channel Nature Park, mile marker 29.5, Big Pine Key
- Upper Sugarloaf Key Trail, end of Crane Boulevard, turn north at mile marker 19.3
- Loop Road Trail, Sammy Creek Landing, mile marker 17, Lower Sugarloaf (south at blinking light)
- Boca Chica Beach, Geiger Key, turn oceanside at mile marker 10
- Key West Tropical Forest & Botanical Garden, mile marker 5, Stock Island

Key West
- West Martello Tower and Key West Garden Club
- Little Hamaca Park and Fran Ford White-Crowned Pigeon Preserve
- Nature Trails on Atlantic Blvd, between Bertha and White Streets
- Sonny McCoy Indigenous Park
- Smathers Beach
- Higgs Beach
- Truman Waterfront Park

Photo right: a great egret rises from a salt pond in the early morning light, No Name Key.

Credits: Stock Images (continued)

Cover (sunset photo), Karuna Eberl
P 86 iStock, Sea Creatures, by Hachio Nora, ID 1322065558
P 96 Adobe Stock, cicada, by Shuttersport, file 432901051
P 98 iStock, Little Bird, by Kristtaps, ID 472296155
P 100, Pixabay, hurricane-1085673
P 110, iStock, Sea Creatures, by Hachio Nora, ID 1322065558

P 116 Adobe Stock, ducks landing, by Yekaztudio, file 580222194
P 120 iStock, binoculars by Magnillion, ID 1337455990
P 122 Pixabay, shark, by BedexpStock
P 134 Adobe Stock, seagrass, by SHERI, file 636428722
P 138 Pixabay, Paddle Kayaking, by Clker-Free-Vector-Images
P 142 – iStock, Diving People Icons, by Irina Gavashenko, ID 1414363591

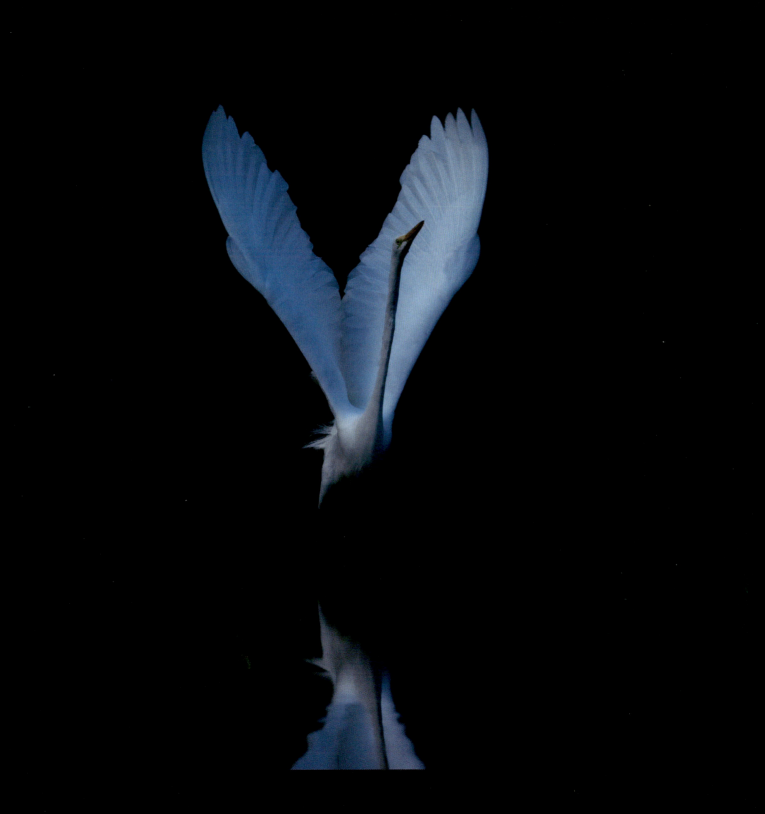

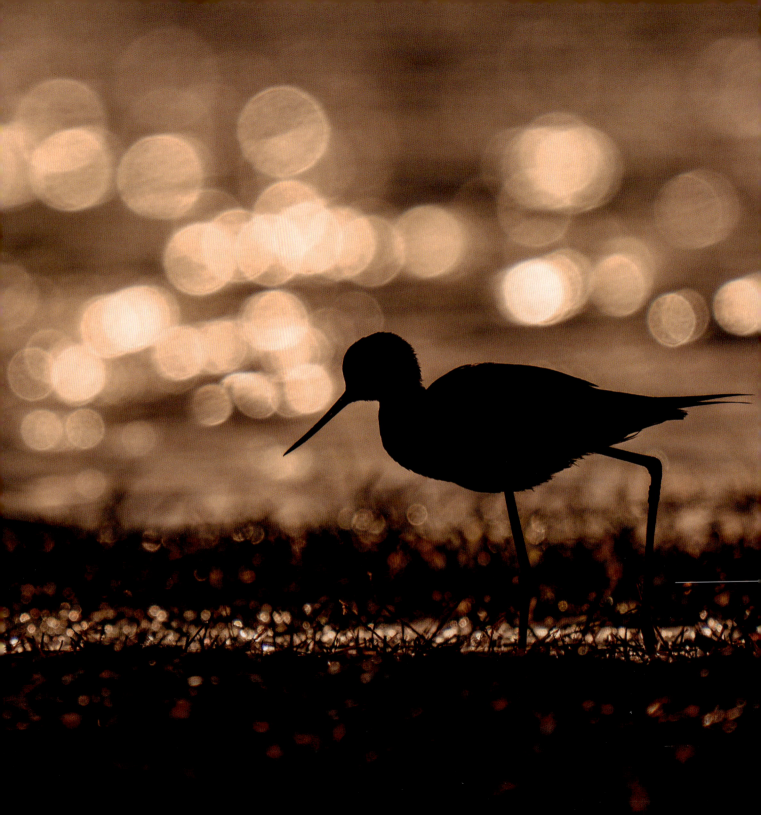

Field Notes & Nature Journaling

Photo left: A black-necked stilt and morning glitter, No Name Key.

Field Notes & Nature Journaling

Field Notes & Nature Journaling

Field Notes & Nature Journaling

Index

Birds

Bunting, painted: 38, **39**
Cardinal, northern: **127**
Egret, great: 110, **149**
Egret, reddish: **44**, **45**, 56, **57**
Falcon, peregrine: 120, **121**
Flamingo, American: **94**, **95**, 130, **131**
Frigatebird, magnificent: 136, **137**
Galanule, purple: **4**
Grosbeak, rose-breasted: 76, **77**
Hawk, red-shouldered: 90, **128**
Heron, great white: 110, **111**
Heron, little blue: **8**
Heron, tricolored: **13**, 56, **57**
Hummingbird, ruby-throated: **12**, 62, **63**, 66, **67**
Ibis, white: 18, **19**
Kestrel: 48, **49**
Kingbird, gray: 96, **97**
Kingfisher, belted: 26, **27**, 114
Kite, swallow-tailed: 118, **119**
Osprey: **5**
Peewee, Cuban: 128, **129**
Pelican, brown: 30, 104, 142, **143**
Pelican, American white: 30, **31**, 114
Pigeon, white-crowned: 90, **91**, 114
Spoonbill, roseate: 40, **41**, 56, **57**
Shorebirds: **145**
Stilt, black-necked: **150**
Teal, blue-winged: 28, **29**, 116, **117**
Vulture, turkey: 132, **133**
Warbler, common yellowthroat: 60, **61**
Warbler, prairie: 98, **99**
Woodpecker, red-bellied: 76, 78, **79**

Fish

Angelfish, gray: 20, **21**
Jacks, bar: 122, **123**
Parrotfish: **3**, 80
Reef: **7**, **20**, 80, **81**, **123**, **147**
Shark, Caribbean reef: 122, **123**
Tang, blue: 80, **81**
Tarpon, Atlantic: 68, **69**

Insects, Mollusks, Etc.

Ant, carpenter: 52, **53**
Bee: **74**
Butterfly, buckeye: **126**
Butterfly, Gulf fritillary: **22**
Butterfly, Miami blue: **52**
Butterfly, monarch: 104, **105**
Butterfly, zebra longwing: **126**
Cicada: 96, **97**
Crab, hermit: 86, **87**
Dragonflies: 32, 72, **73**
Moth, faithful beauty: 74, **75**
Snails, tree: 78, **84**, **85**
Spider, orb weaver: 82

Mammals

Key Deer: **12**, 16, **17**, 32, 34, **35**, 70, **71**, 76, 78, 92, **93**, 104, 114, **115**, 132, 144
Manatee, West Indian: 134, **135**
Rabbit, Lower Keys marsh: 10, **11**, 32, 104, 124, **125**
Raccoon: **42**, 76, 90
Woodrat, Key Largo: 140, **141**

Other

Bahia Honda: 50, **51**
Blue Hole: 36, **37**, 128
Florida Keys, info/conservation: 8, 10, 12, 16, 22, 24, 26
Henry Flagler Overseas Railroad: 50, **51**
Hurricanes: 76, 92, 100, **101**, 102, 104, 106, **107**, **108**, **109**, 110, 112, **113**, 114
Key West Tropical Forest & Botanical Garden: 22, **23**, 58, 148
Lighthouse. Sombrero reef: **147**
Limestone: **32**, **33**, **35**
Migrations: 8, 28, 30, 60, 62, 76, 82, 114, 116, 118, 120, 130, 144
Milky Way Galaxy: 50, **51**
Motus Wildlife Tracking System: 38
Seasons: 24, **25**, 58, 78, 100, 114
Storm: **14**

Plants & Trees

Blue mistflower: 104, **105**
Creeping Charlie: 127
Goatweed: **126**
Gumbo limbo tree: 76, **77**, 82, **83**, 106, **107**
Hardwood hammock: 82, **83**, 88
Lignumvitae: **12**
Mangroves: 36, 86, 90, 92, **93**, 94, **95**, 98, 102, **103**, 108, 110, 136, **139**
Marsh pinks: 58, **59**
Orchid, Florida butterfly: 78, 88, **89**
Pine rocklands: 32, **33**
Pisonia tree: 74, **75**
Poisonwood: 90, **91**
Seagrape: **24**, **25**, 90
Seagrass: 80, 134, 138
Senna, Bahama: **52**
Wildflowers: **52**, 58, **59**, 82, 104, **105**

Reptiles

Alligator, American: 32, 34, 36, **37**, 78, 138, 144
Anole, green: **12**, **64**, **65**, 66, **67**
Anole, Cuban: **48**, 64
Crocodile, American: 36, 78, 104, 144
Snake, red rat: **54**, **55**, 90
Turtle: **23**, 32, **104**
Turtle, sea: 46, **47**, 78, 80

About the Artist

Kristie Killam is a retired park ranger, biologist, and teacher who has been an outdoor enthusiast and conservationist her entire life.

For the past decade, she has been using photography to tell the stories of nature in the Florida Keys, capturing the beautiful art that is our local wildlife, habitats, and landscapes.

Her passion is, through photography and education, to engage and inspire others to become stewards of and voices for nature.

Photographer & Author Kristie Killam.
Published by Quixotic Travel Guides.
ISBN: 978-0-9988589-5-1
1st Edition printing
© Kristie Killam, 2025
Photographs copyright as indicated 2025.
Printed in the United States of America.
All rights reserved.

If you like this book, please review it so others can find it and enjoy the nature of the Florida Keys, too.